ART & SOLE

ART&SOLE

JANE GERSHON WEITZMAN

PHOTOGRAPHY BY
LUCAS ZAREBINSKI

HARPER DESIGN
An Imprint of HarperCollinsPublishers

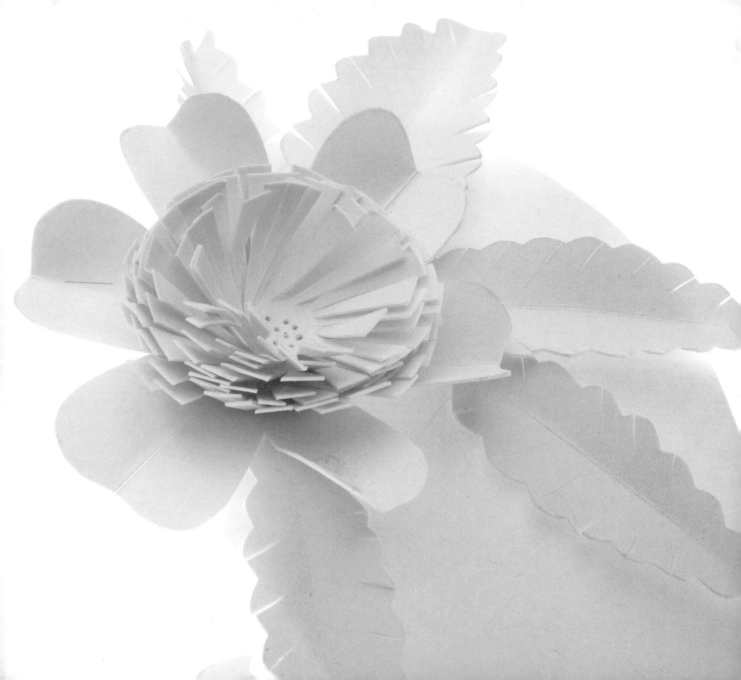

To my husband, Stuart,
whose love of shoes is infectious

CONTENTS

INTRODUCTION

In the winter of 1995, my husband, shoe designer Stuart Weitzman, told me that we were going to open our first retail store on Madison Avenue in New York City and asked me to look at an available space near Fifty-ninth Street. I did, and when I confirmed that the location was right for the shop, he responded by telling me to make sure that it was ready to open by the first week in August. Suddenly, after spending years handling public relations, event planning, and all the other things that no one else in our company could or wanted to do, I found myself in the retail business. There I was, hiring the architect and designer, setting up the space, and determining how we would brand ourselves to the public. This was quite a challenge, because if the shop didn't do well, it would be a very public failure—and I could not allow that to happen!

I grew up in Atlanta during the time when the great department store Rich's, then a family-owned operation, was the model for retail. I took a cue for our store from my experiences there, especially regarding customer service. While the importance of being nice to your customers may seem obvious, I knew I could not stress it enough to our staff. I wanted to make sure our shop was a place where salespeople not only made customers feel welcome but also were glad to help them find both the right shoes and the right fit. I wanted to make sure our customers never felt any pressure to buy and to make it easy for them to see the prices of the merchandise. More than anything, I wanted shopping in our store to recall the same graciousness and warmth I had experienced growing up in Atlanta and to bring some of that southern hospitality to Madison Avenue.

Once Stuart Weitzman opened, I made sure that it was fun to shop there. When I came across items such as chocolate shoes, or gift wrap with shoes on it, or even books about footwear, we sold them. After a while, people came to the store to buy those gift items as well as shoes and accessories.

I also oversaw the window displays, which featured fantasy shoes made by wonderful artists from all over the world. This was not my first experience working with artists on behalf of our company, though. In the mid-1980s, I went to many studios in New York City with a young photographer, Tali Katzurin, to photograph Stuart's shoes in combination with sculptures by artists such as Michele Oka Doner, Tobi Kahn, and Jackie Ferrara for a series of advertisements, "The Art of Stuart Weitzman," that we ran in *Vogue*. In those days, we rode in a lot of freight elevators in lower Manhattan in our search for artists for that campaign.

Before long, I began to travel around the country looking for artists to make fantasy shoes for our store windows. This book, *Art & Sole*, is the result of many years of hard work and fun that went into creating those displays.

The response to my search for artists was extraordinary from the very start. There was a sense among the people I approached that they were part of something exciting,

and that displaying their work in our windows was as thrilling as having a one-person show at a prestigious New York gallery. At the time, we did consider the windows a gallery of sorts and sold some very good pieces. Later on, though, we regretted selling them, but then we had no idea that we were putting a collection together that would travel to new Stuart Weitzman stores in other cities.

While some of the artists already made "art shoes," most of them did not—and in the latter cases, there was something I saw in their work that I thought would translate into a creative window display. In order to make sure the shoes reflected Stuart's designs, I asked him to draw a simple outline of a high-heeled pump. I took the sketch with me to craft shows and other venues where I searched for new artists.

As I spent more time looking for artists and building our collection, the shoes became stronger. The challenge was to keep raising the creativity level and to make the shoes we intended to exhibit even more extraordinary than the last group. I found very talented artists who made shoes out of unexpected materials, and I always urged them to take their work further. In 2000, when Timothy Fortuna became our window designer, he soon joined me in searching for more artists, always encouraging them to push themselves, too. He created wonderful backgrounds for the shoes, changing the displays monthly. He even created some shoes himself.

Finding the artists became addictive for us—as was the thrill of seeing their finished pieces.

Our customers loved the shoes. There were often crowds standing in front of the windows, looking in. Tim and I frequently stood outside within earshot so we could listen to people's reactions and observations. Their excitement and comments motivated us to bring in even more showstopping shoes for them.

Before long, the windows became a destination, and artists, or their friends who had passed by, began to inquire about making shoes for the displays. Once we began to get media coverage, we heard from artists from all over the world—even from those who had never created fantasy shoes before—who wanted to make special pieces for us. When *Women's Wear Daily* wrote about the windows, we received many sketches and photographs, although sadly, most of them were just not up to our standards. Oddly enough, in light of the huge popularity of the Cinderella story, I was never able to find glass shoes, but it was not from a lack of trying. The ones that came our way never quite worked out.

The shoes that I have selected to include in *Art & Sole* represent the best of more than a thousand that have appeared in Stuart Weitzman stores over the years. I hope you enjoy looking at them as much as I enjoyed working with the very special artists who created them.

THE SHOES

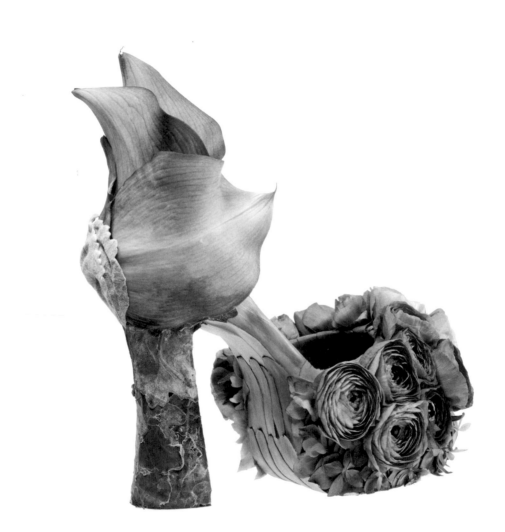

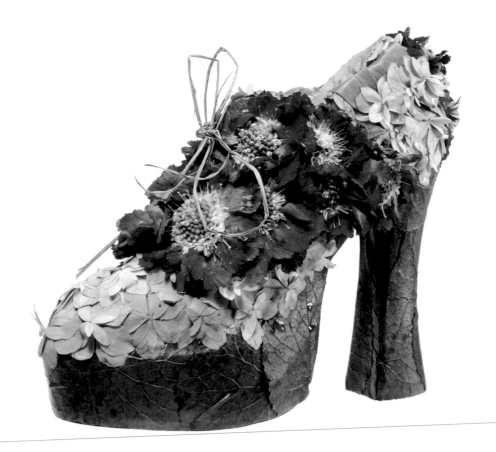

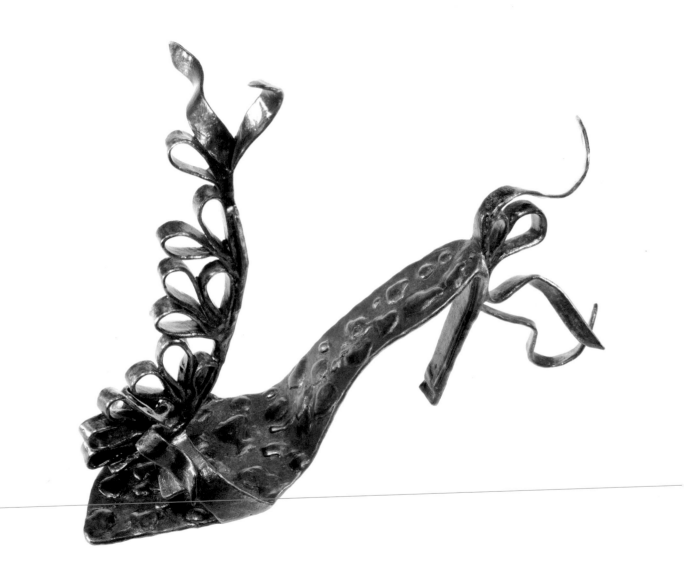

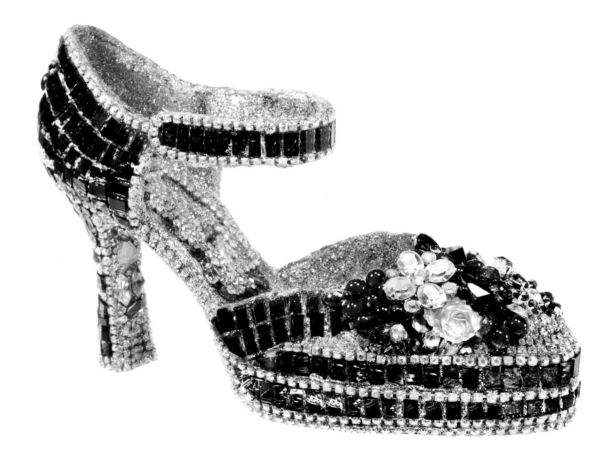

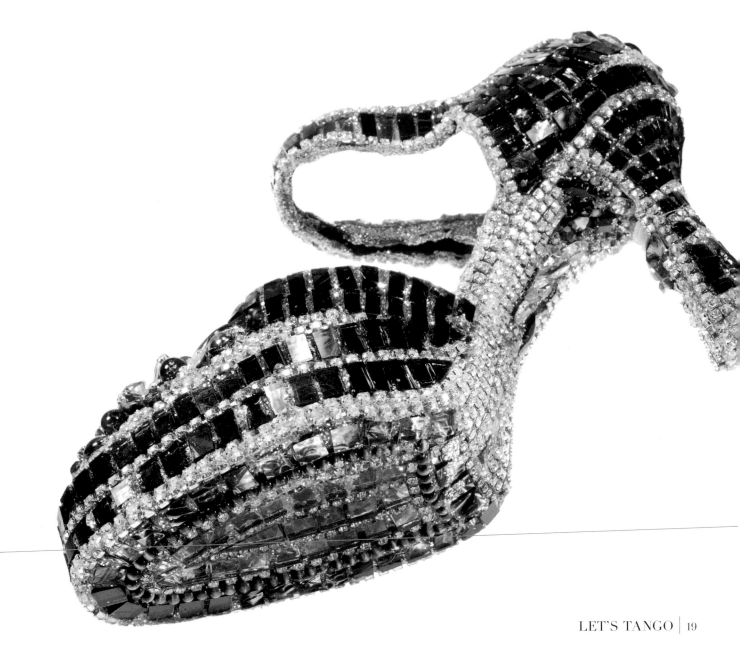

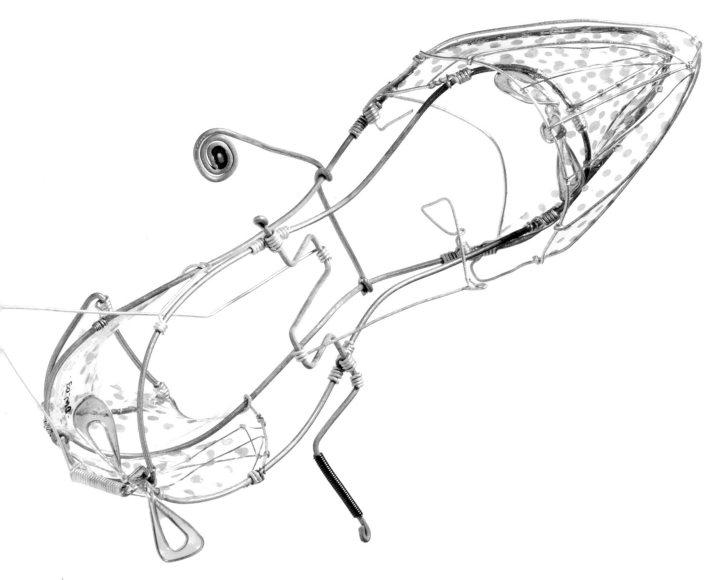

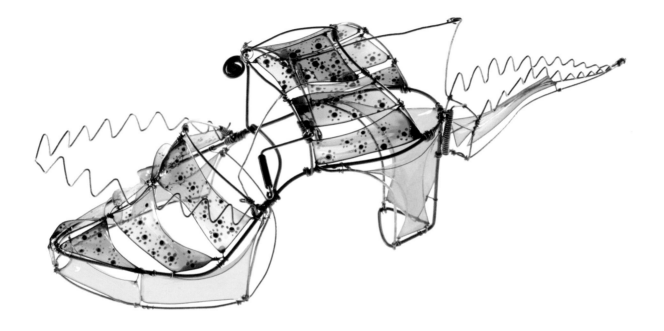

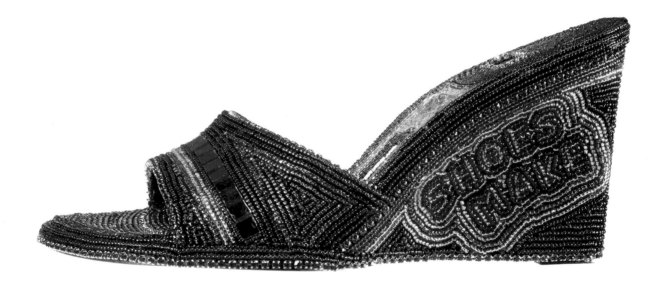

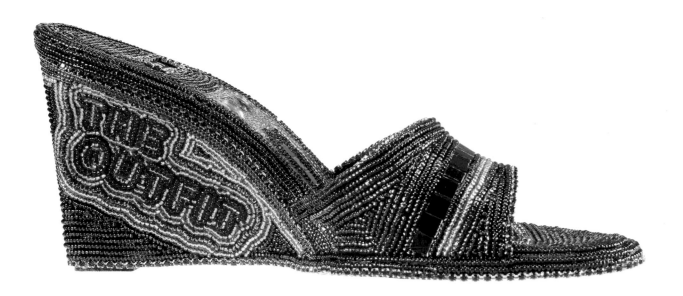

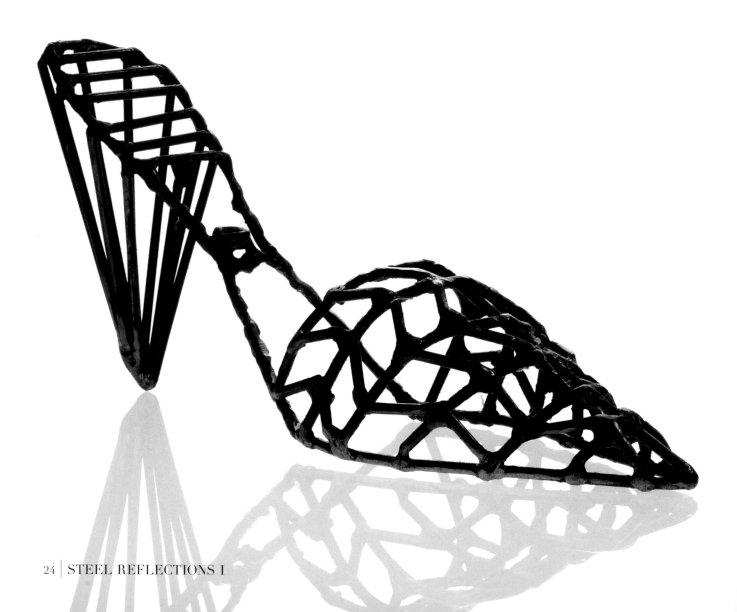

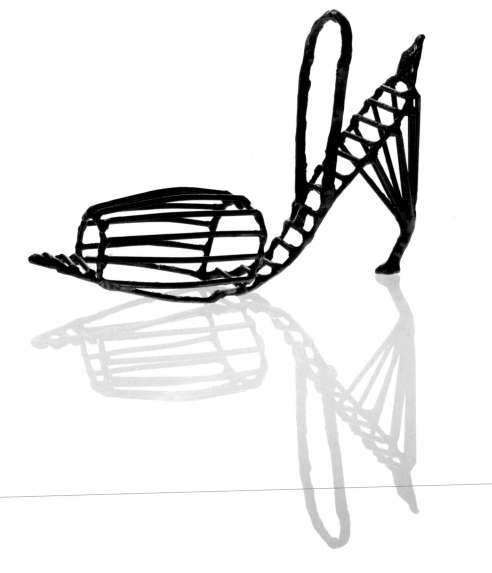

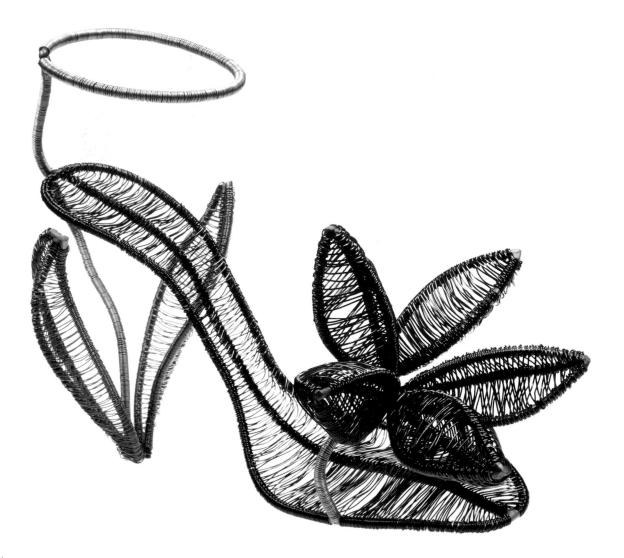

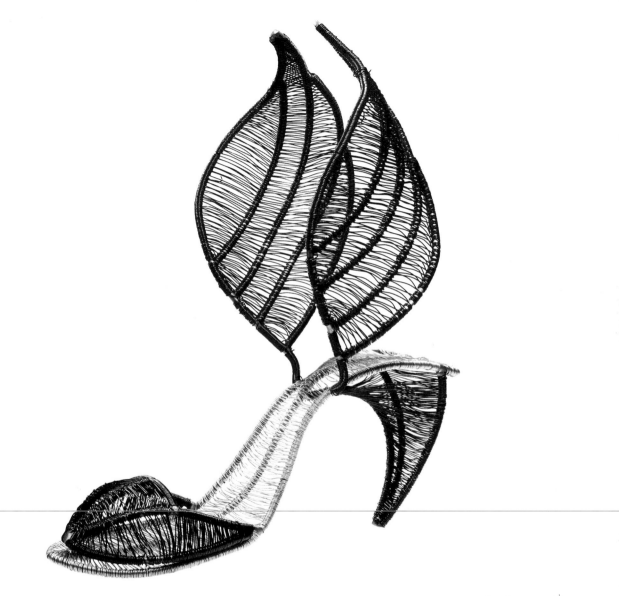

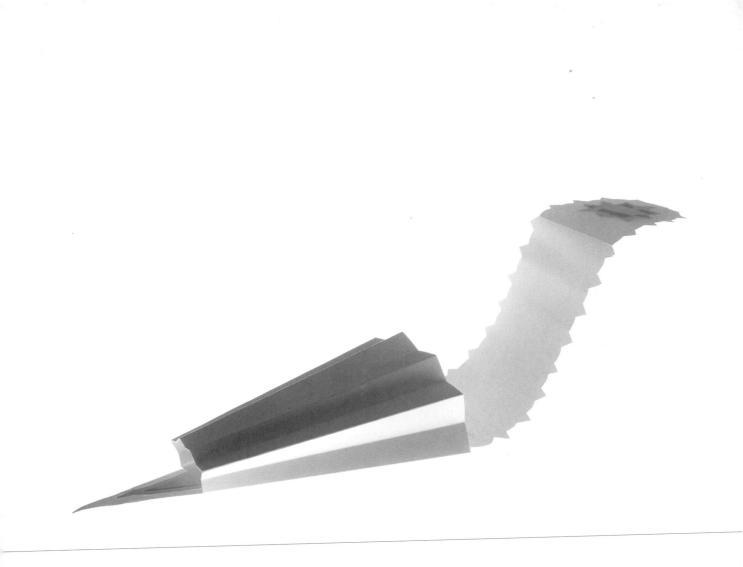

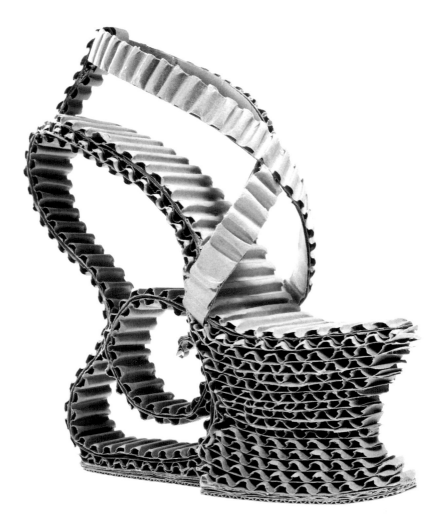

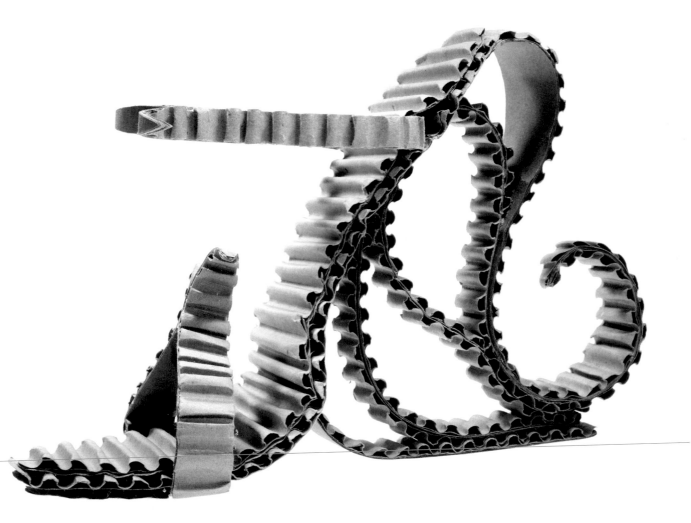

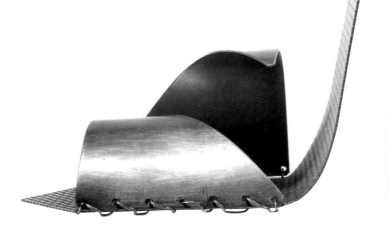

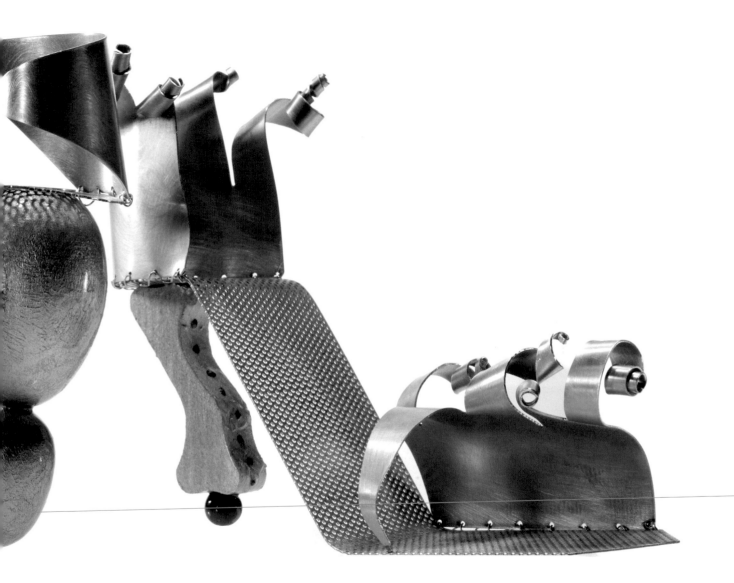

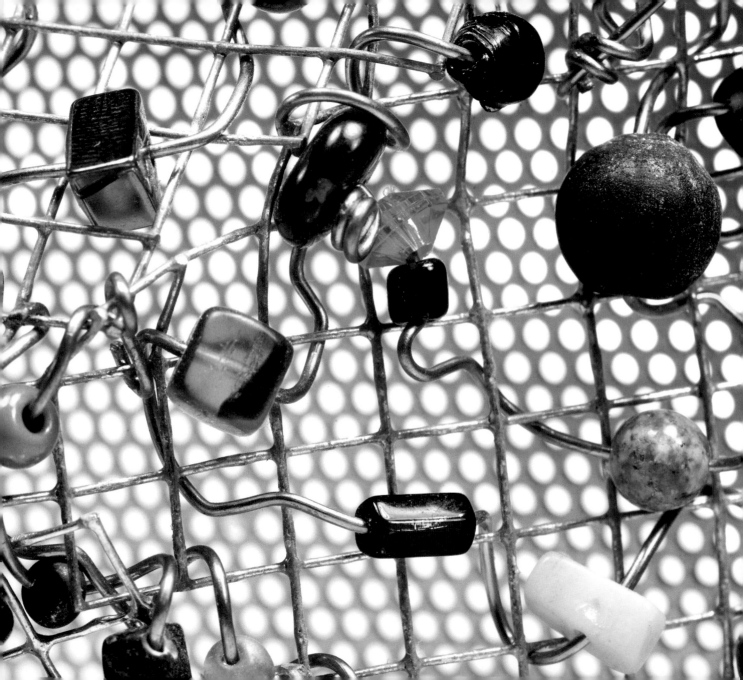

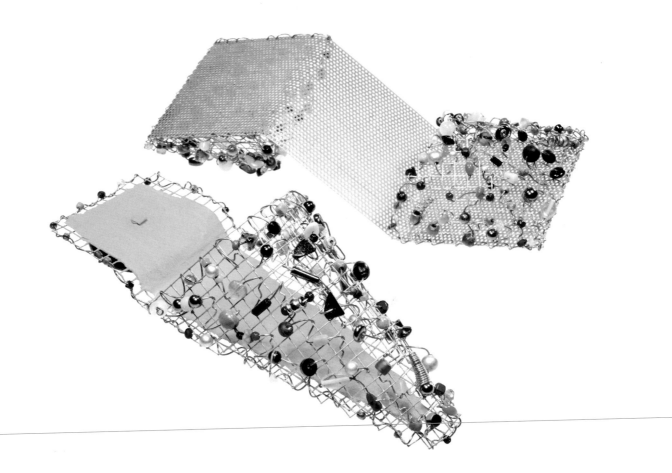

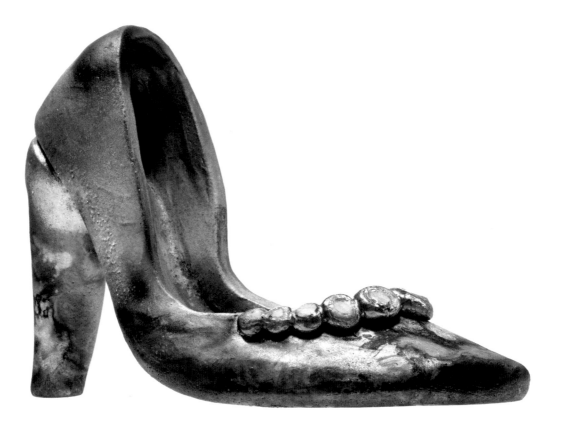

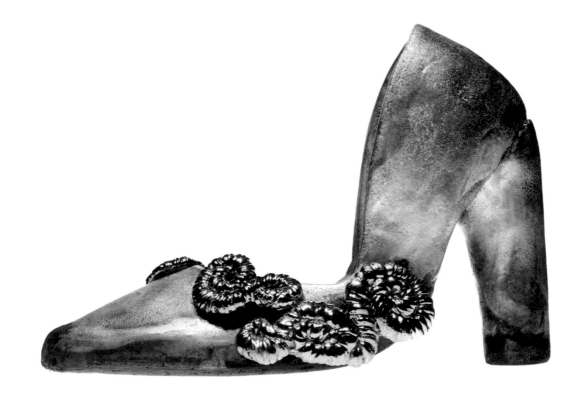

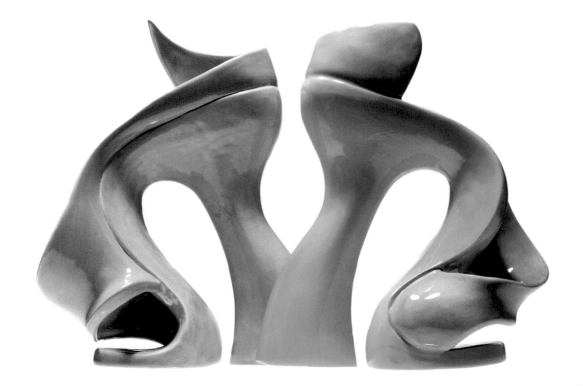

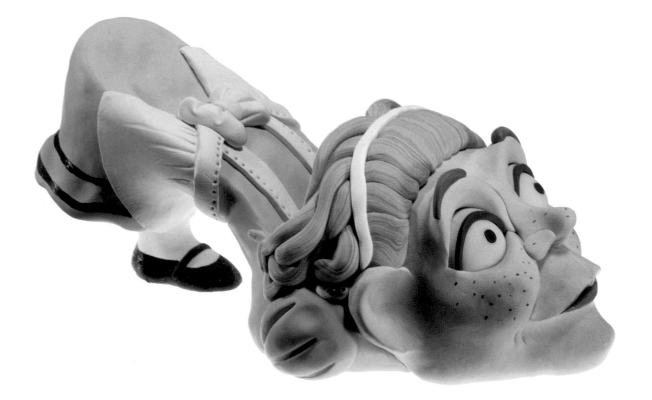

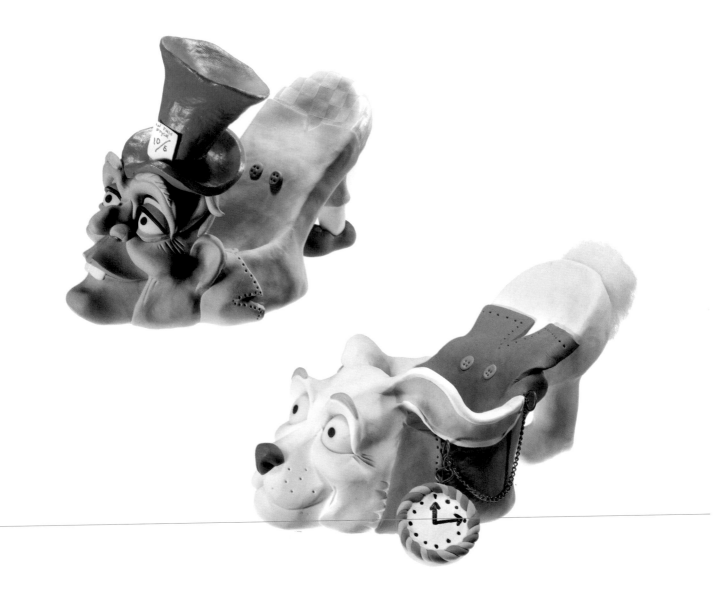

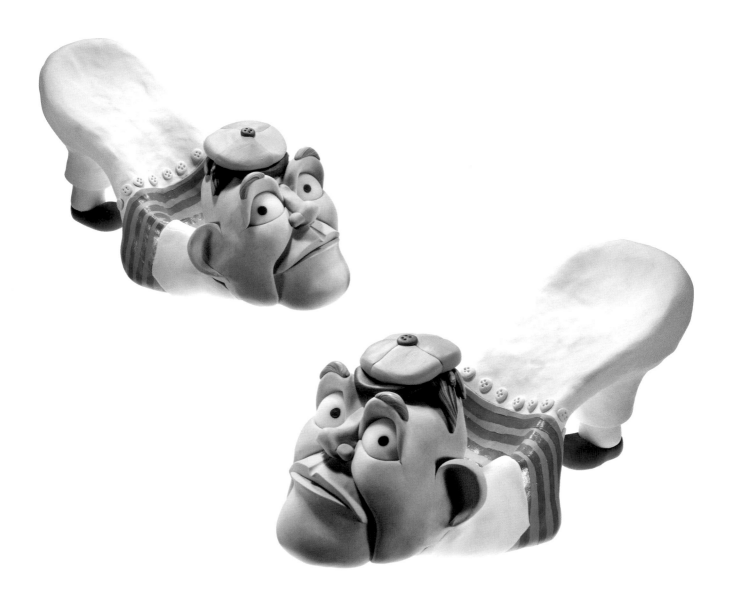

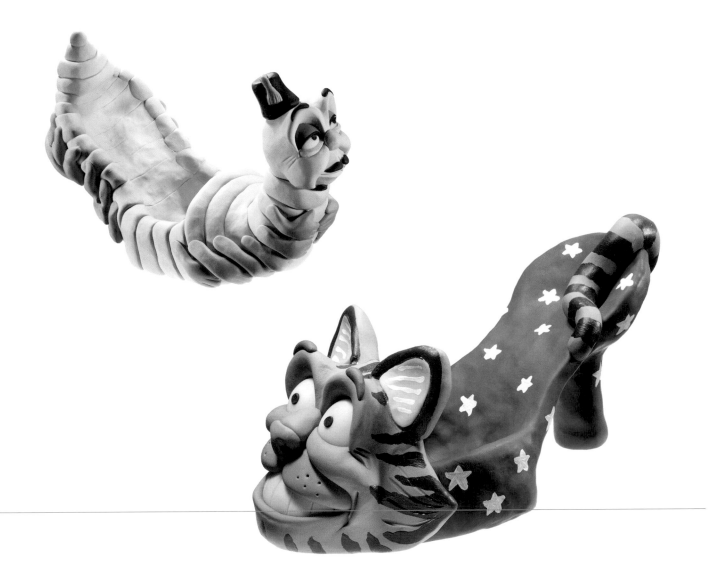

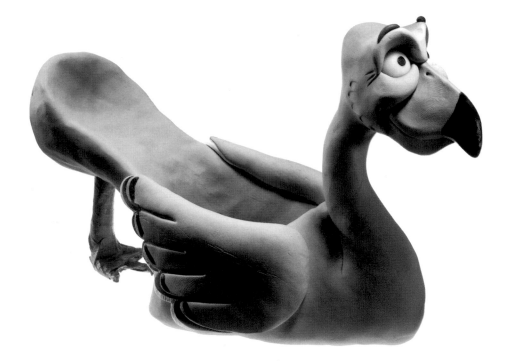

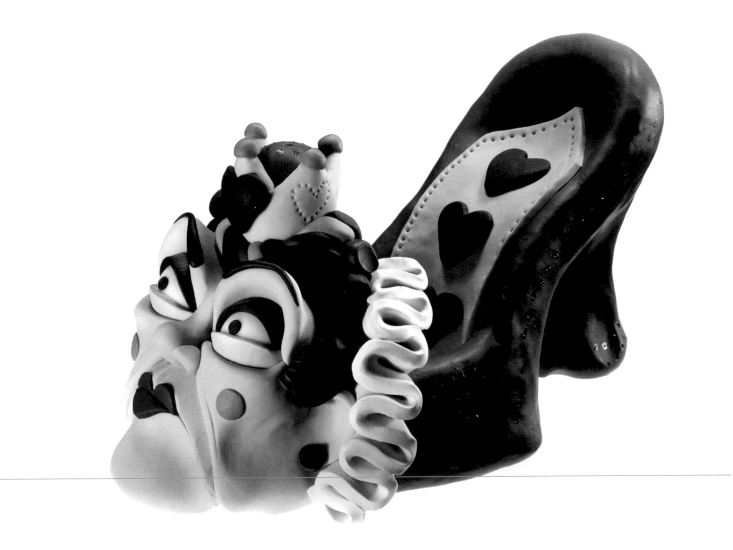

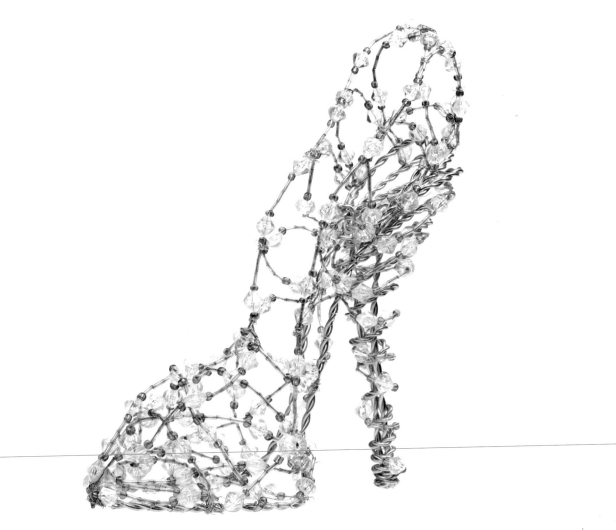

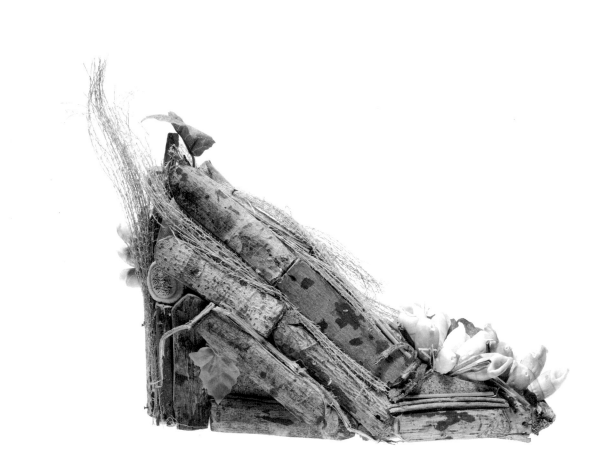

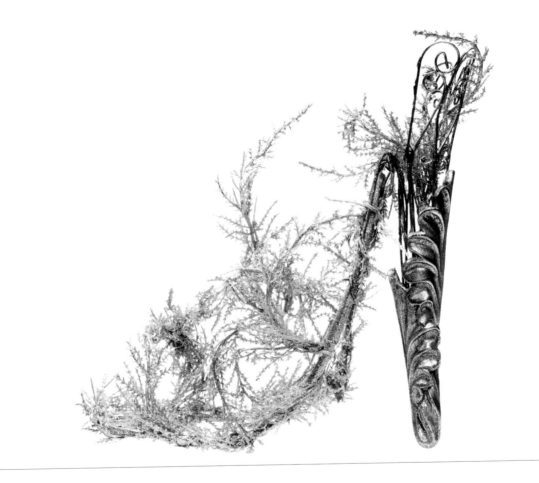

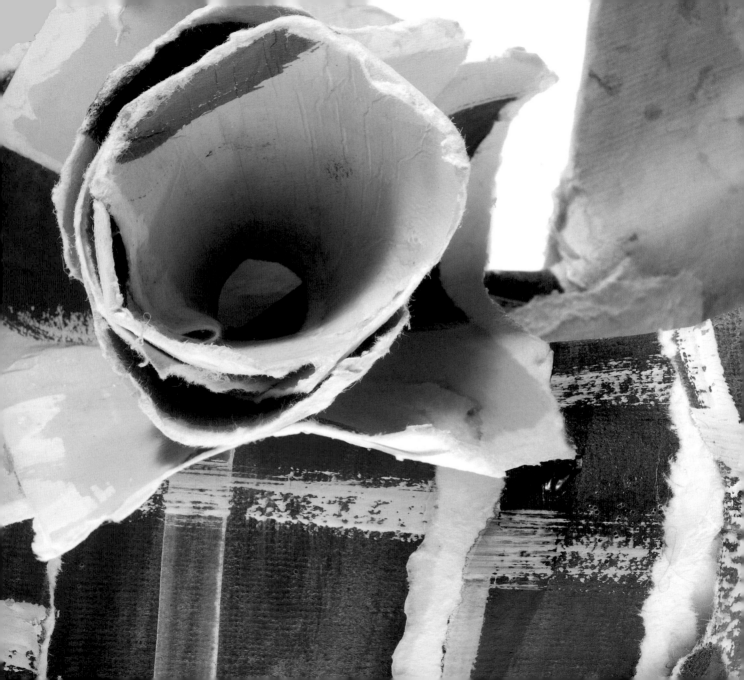

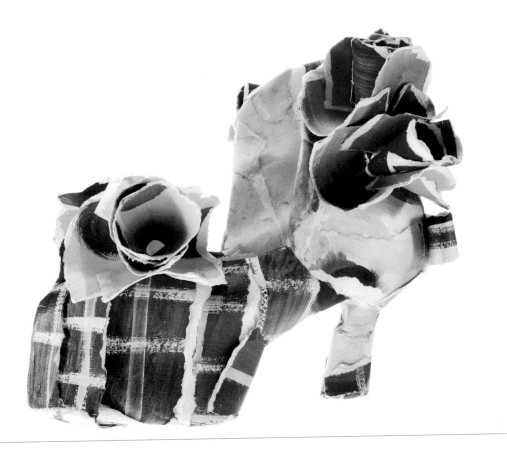

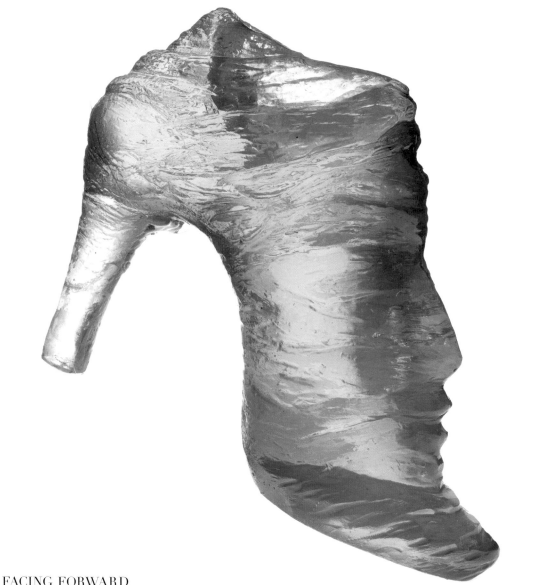

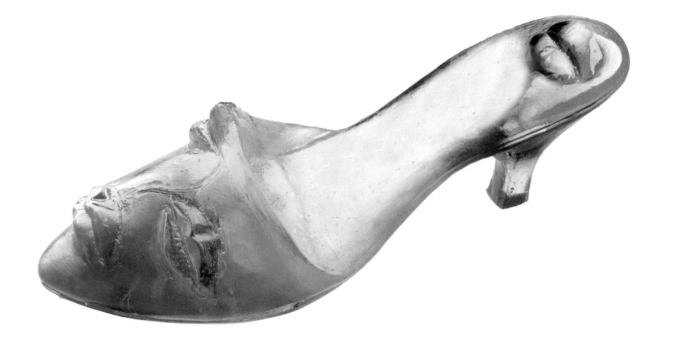

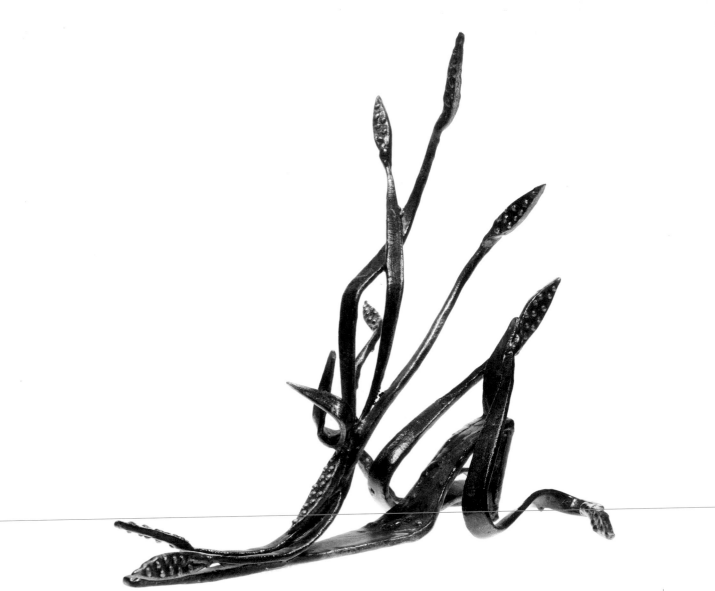

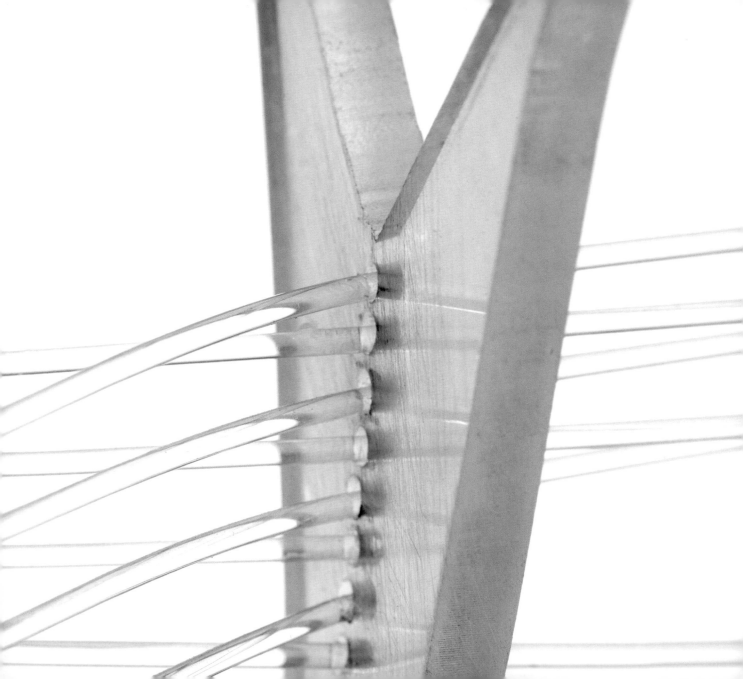

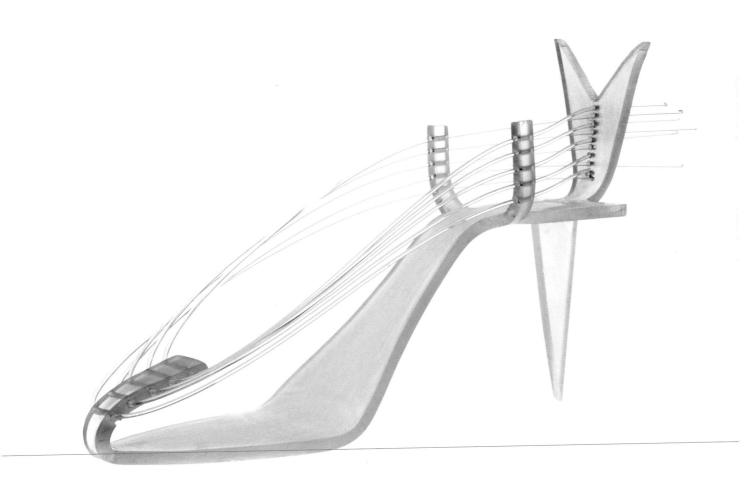

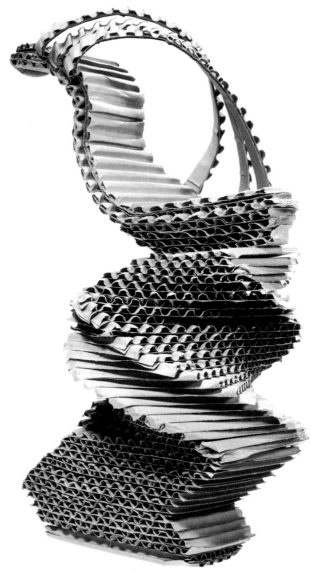

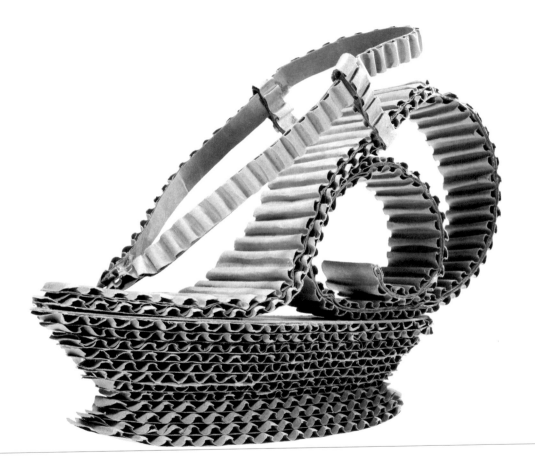

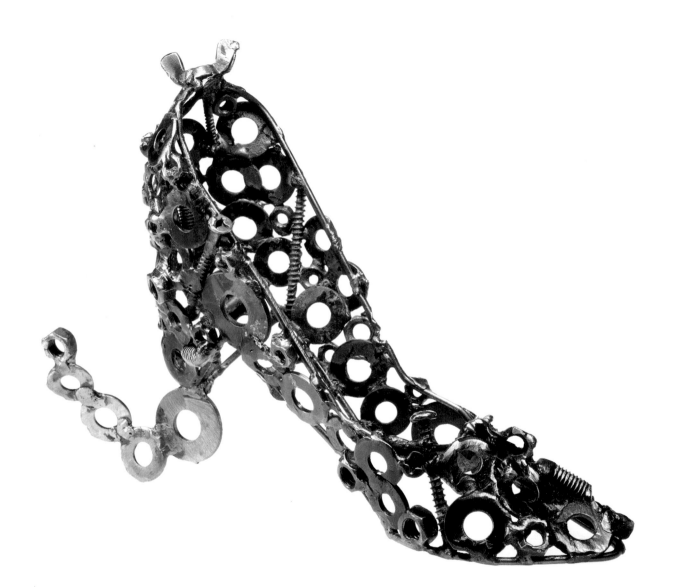

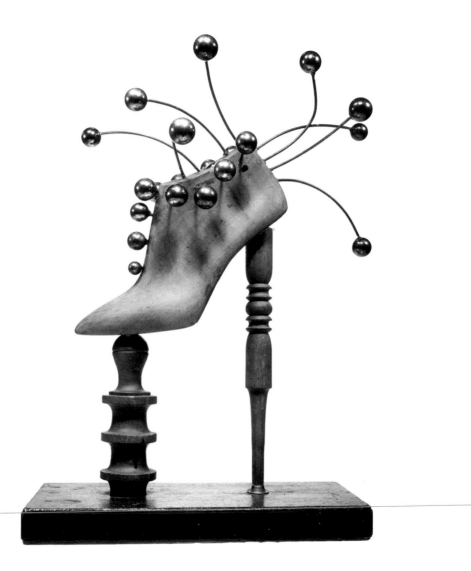

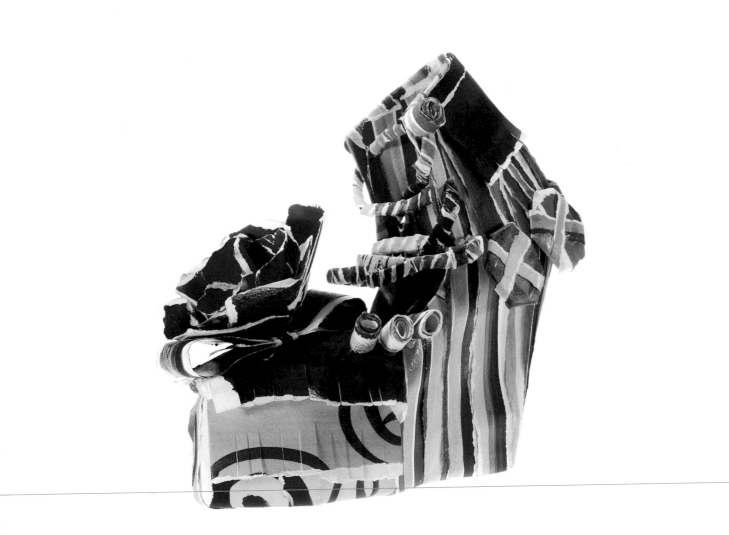

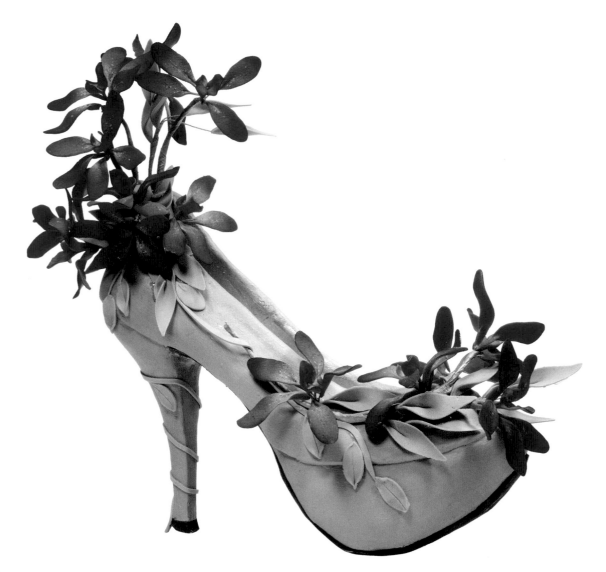

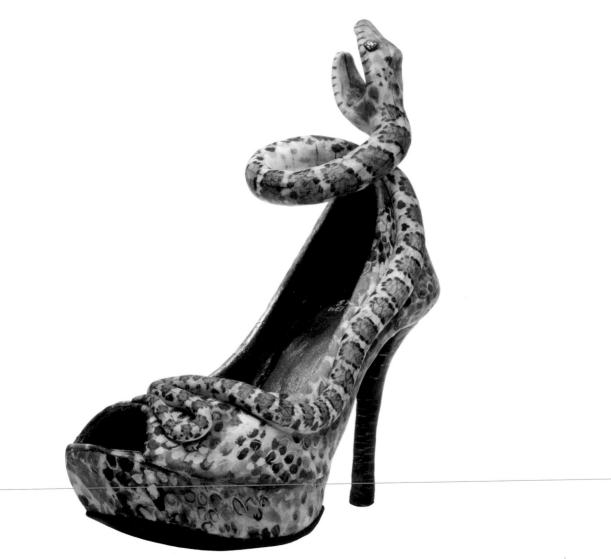

SNAKE CHARMER | 67

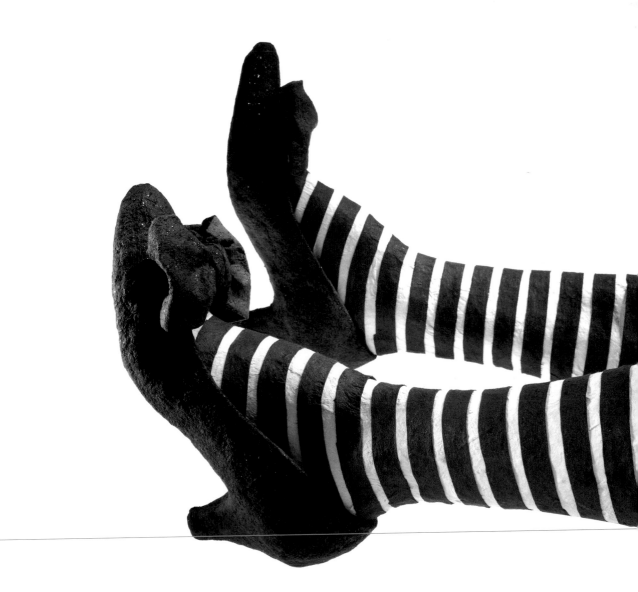

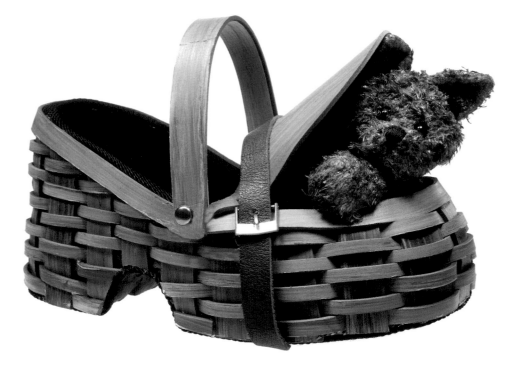

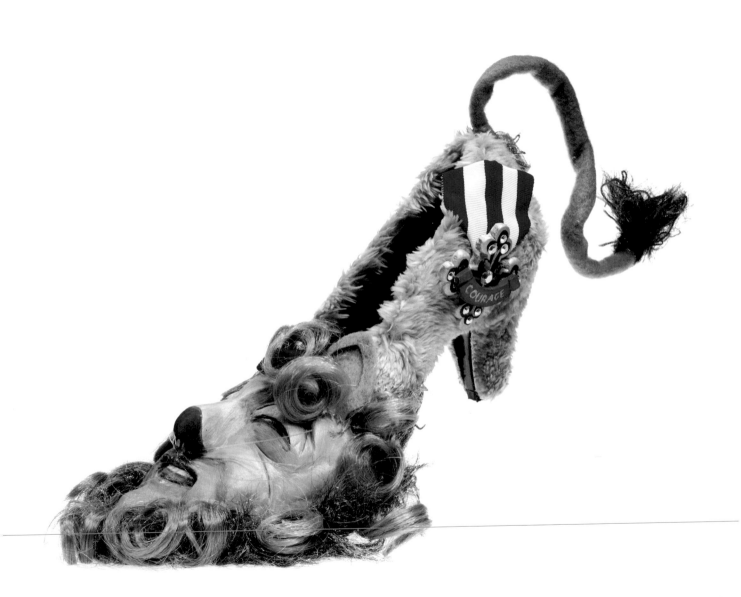

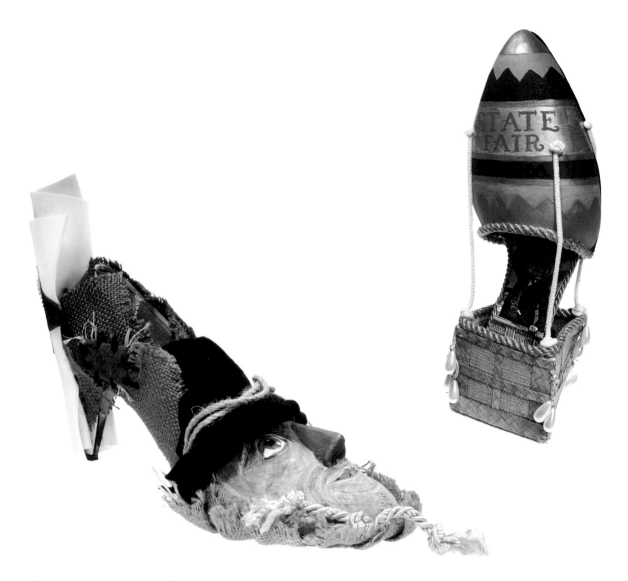

| LEFT: SCARECROW | RIGHT: STATE FAIR

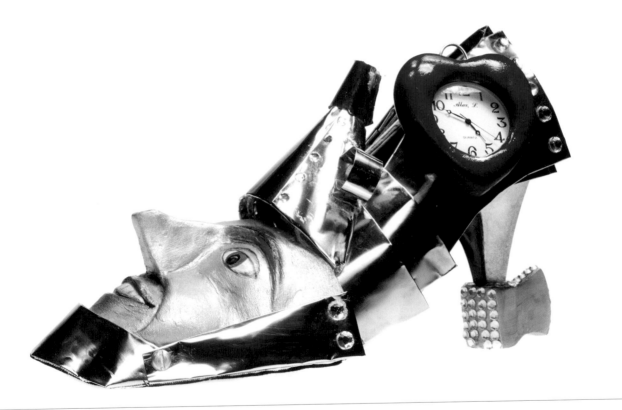

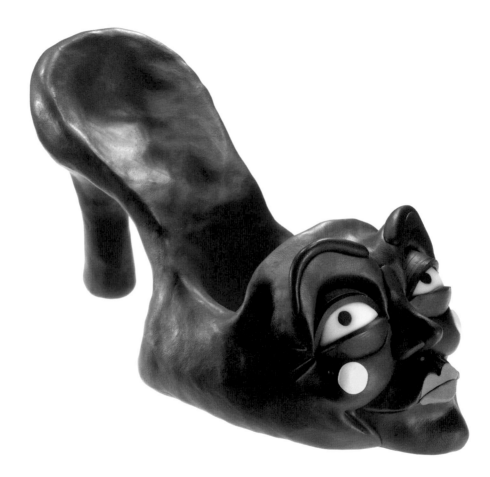

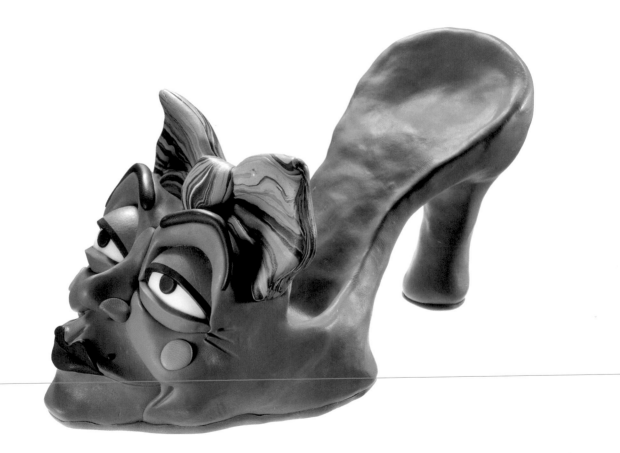

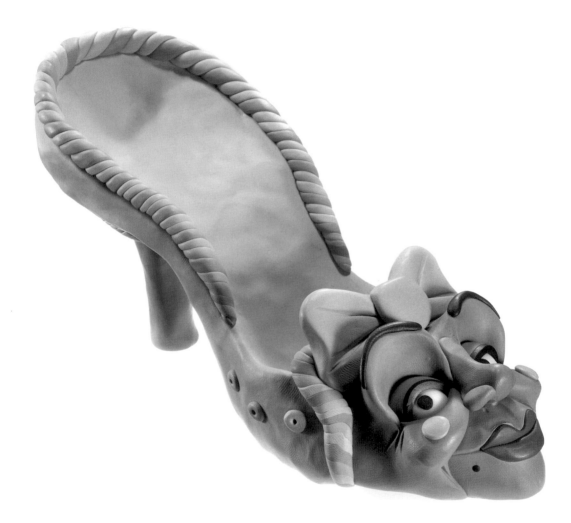

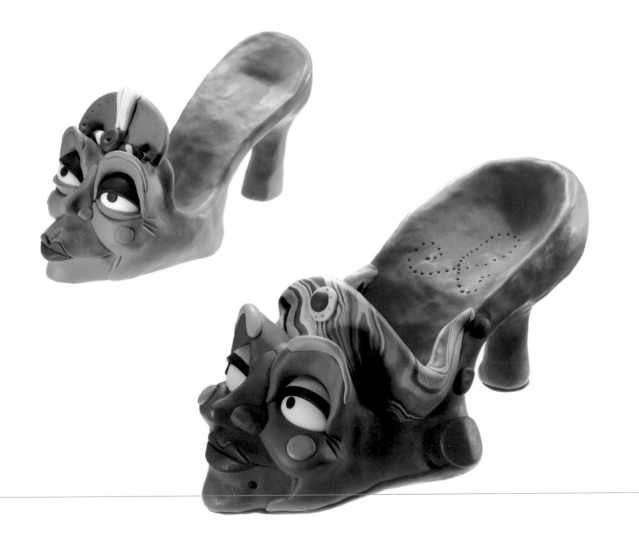

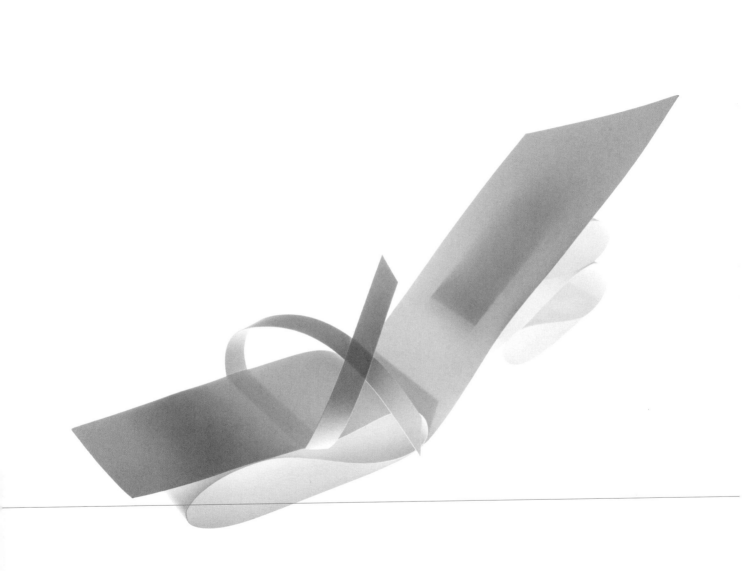

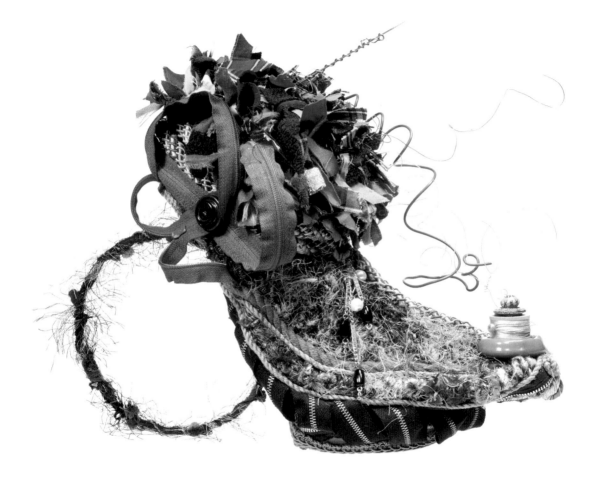

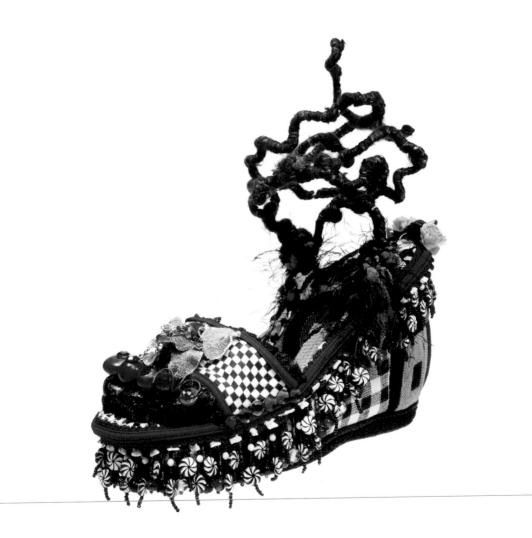

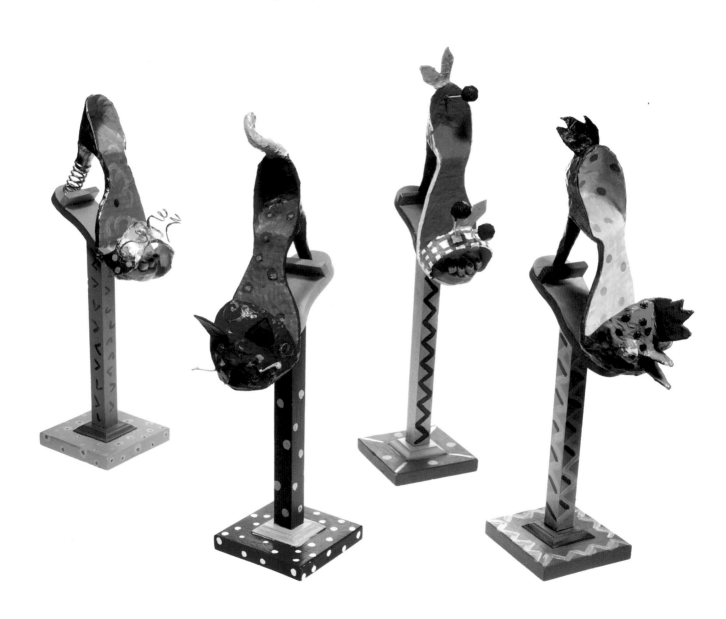

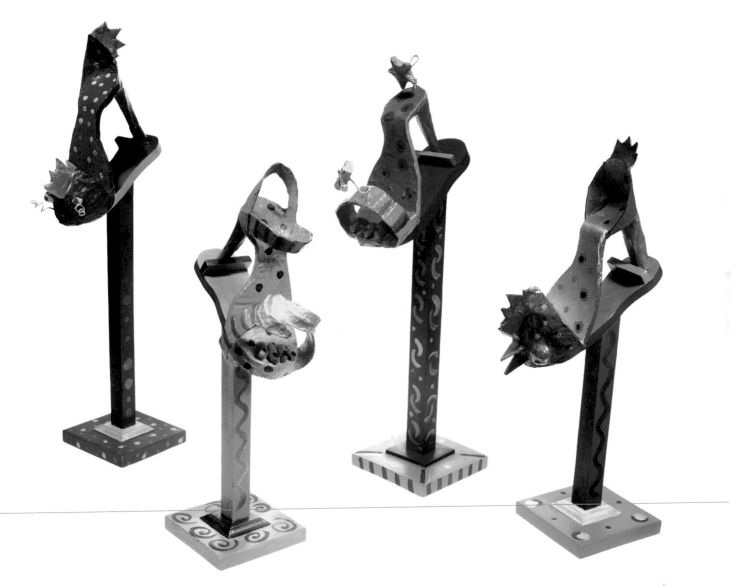

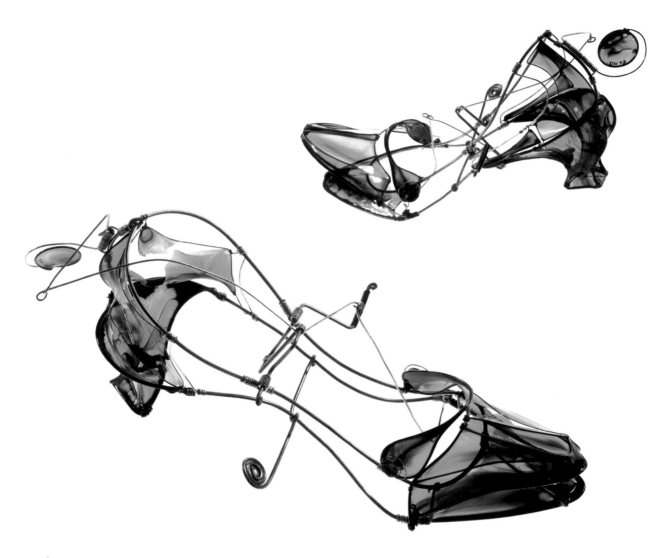

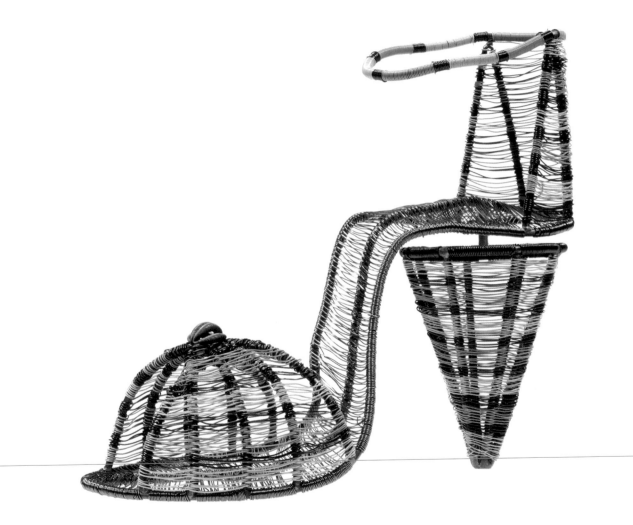

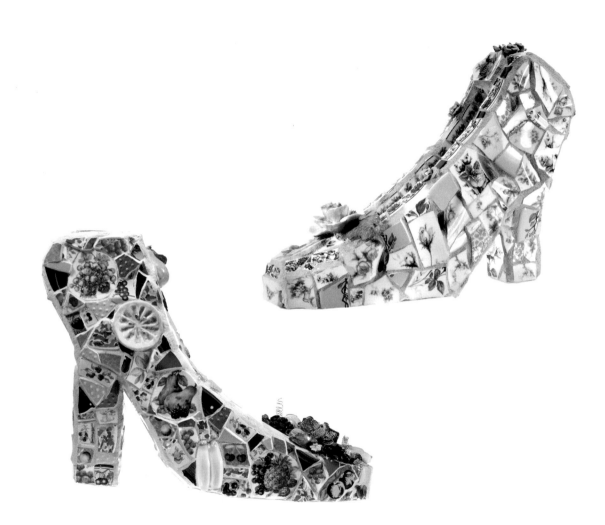

| TOP: SHOEZAIC | ABOVE AND OPPOSITE: FRUIT SALAD

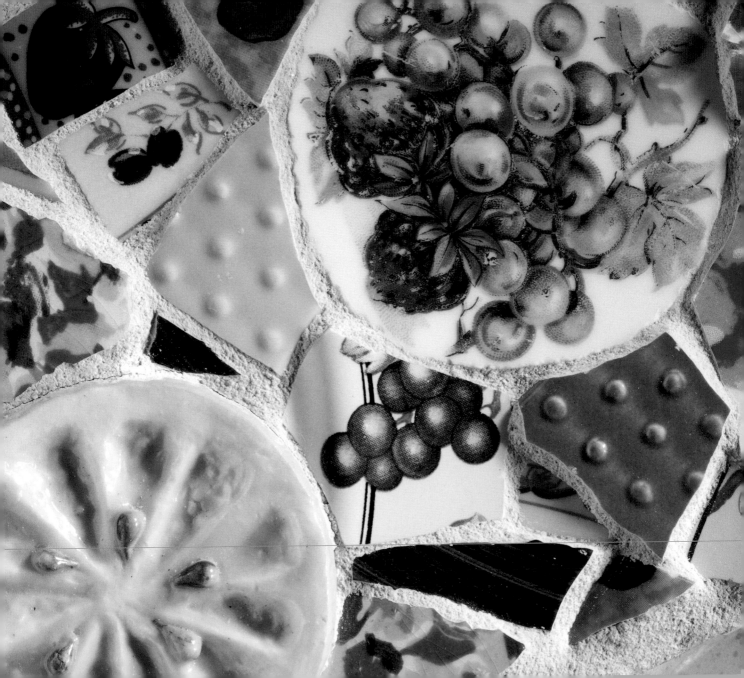

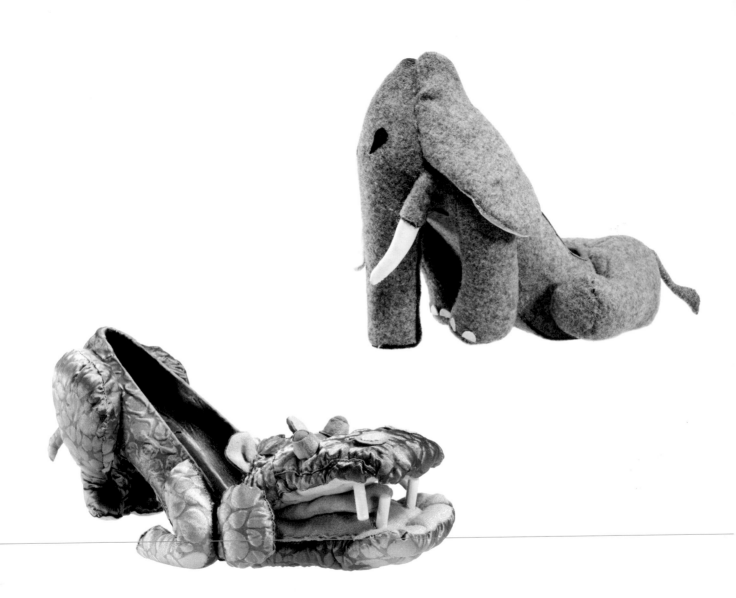

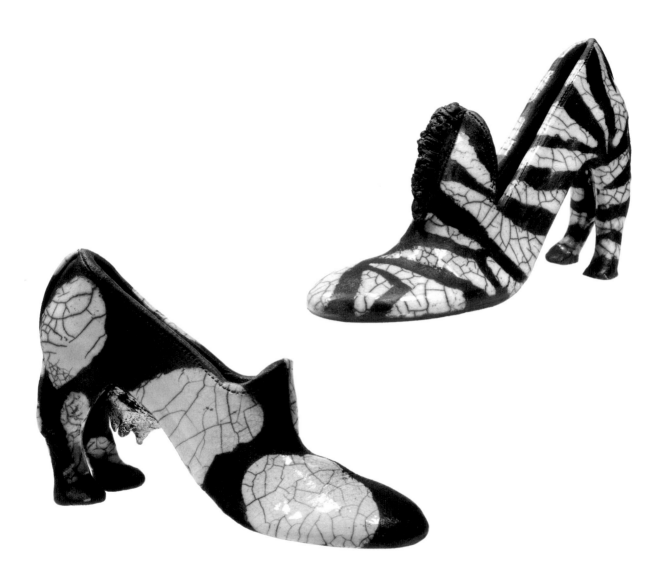

| TOP: EARN YOUR STRIPES | BOTTOM: UDDERLY DIVINE

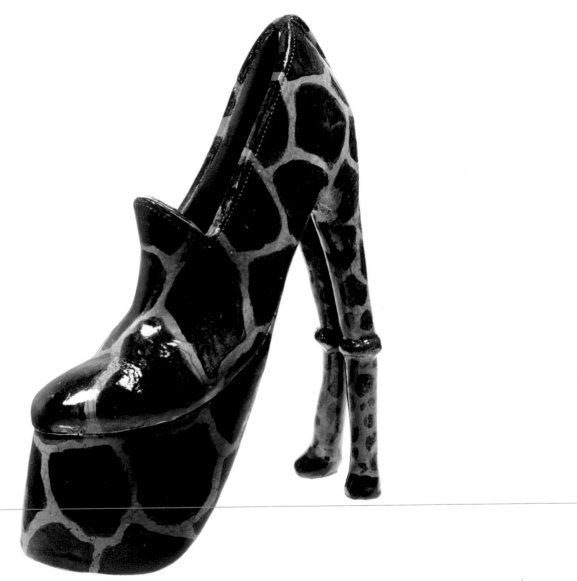

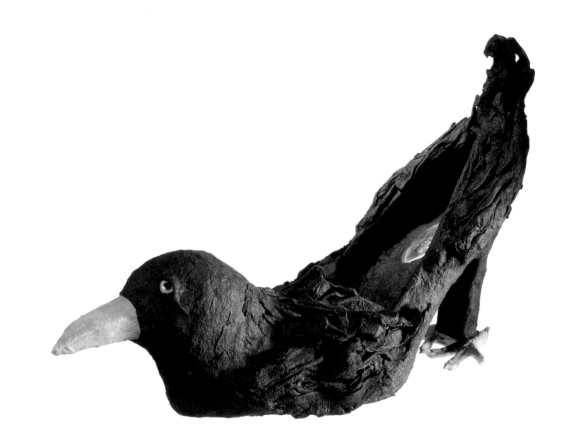

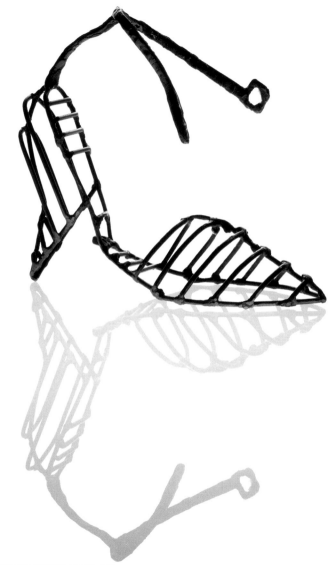

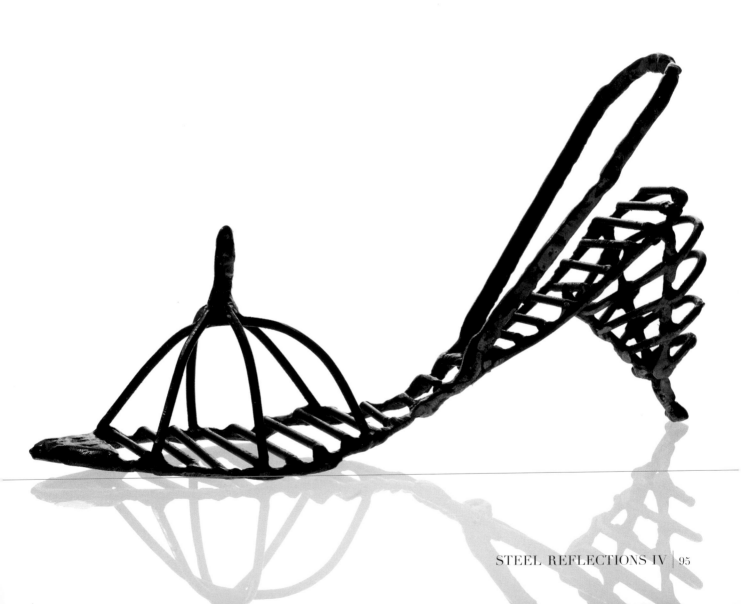

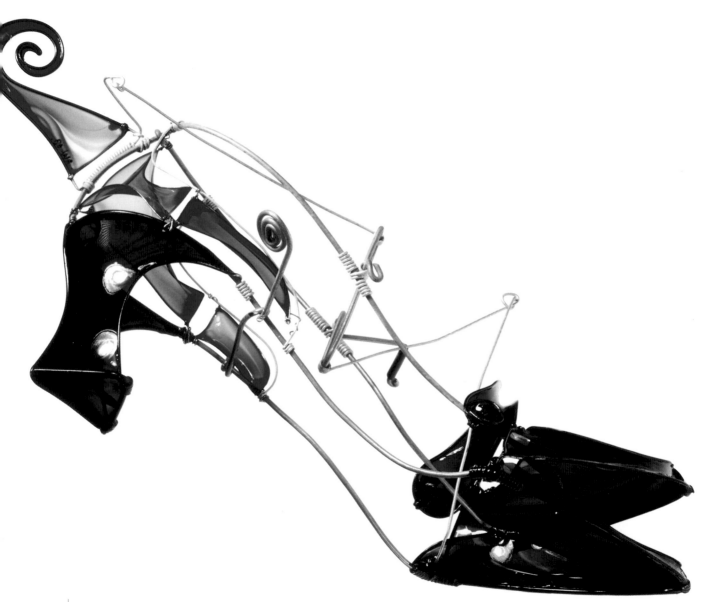

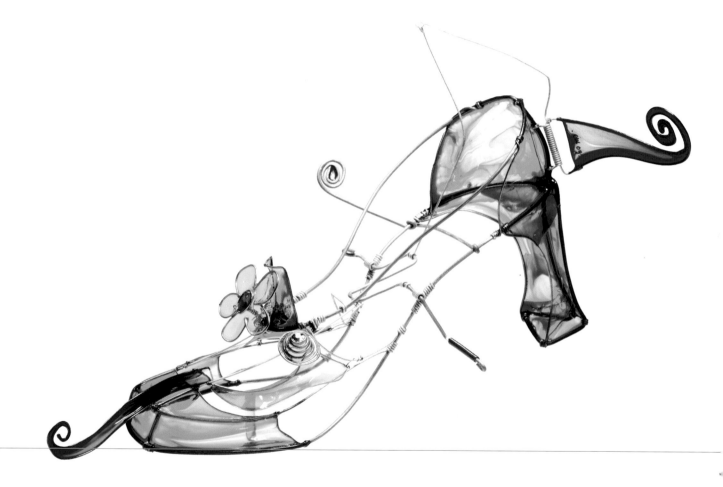

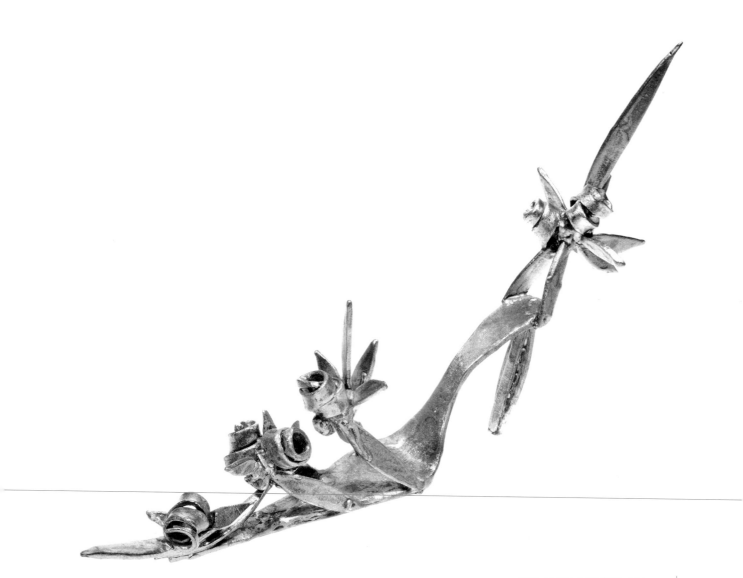

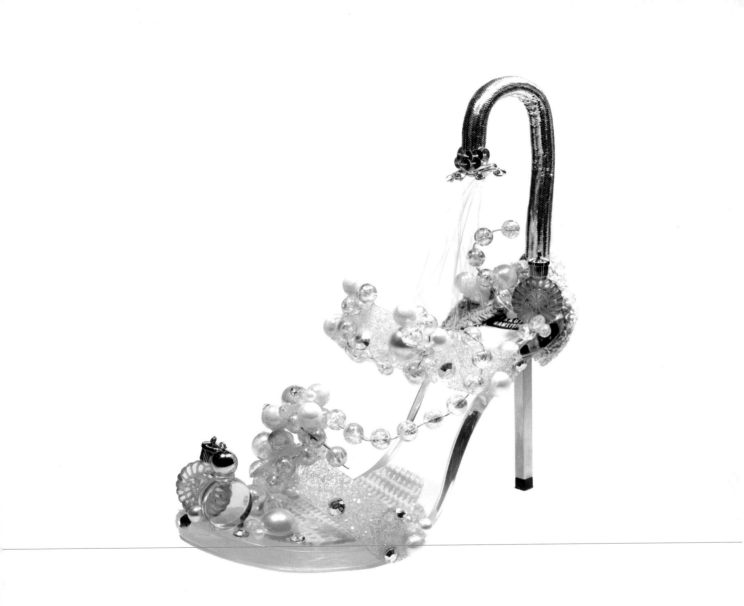

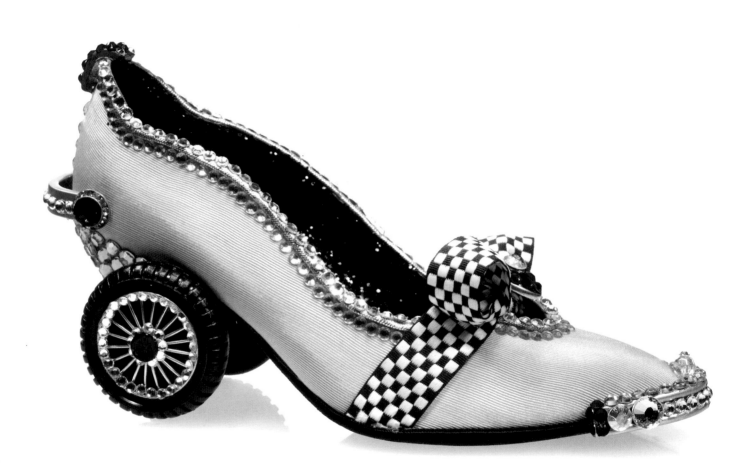

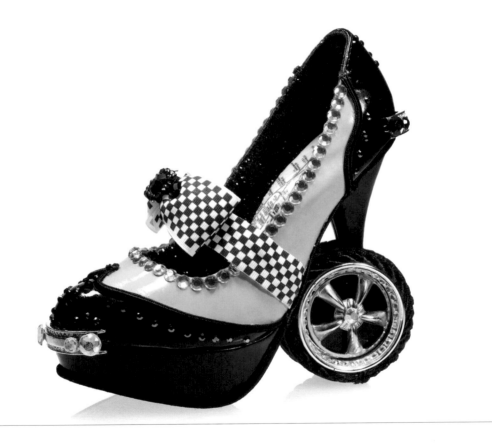

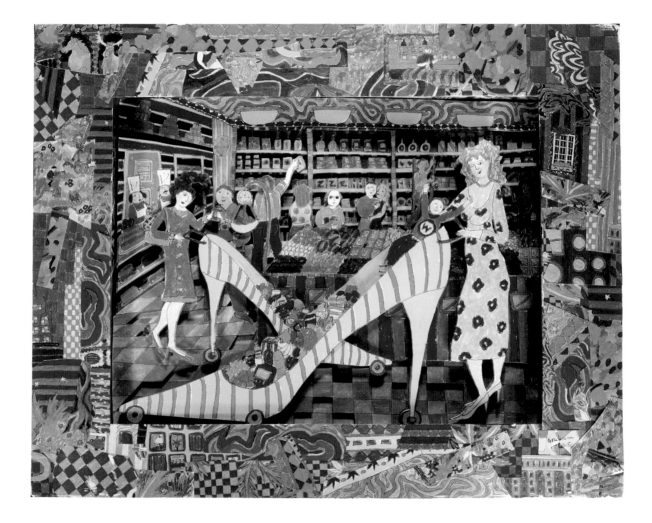

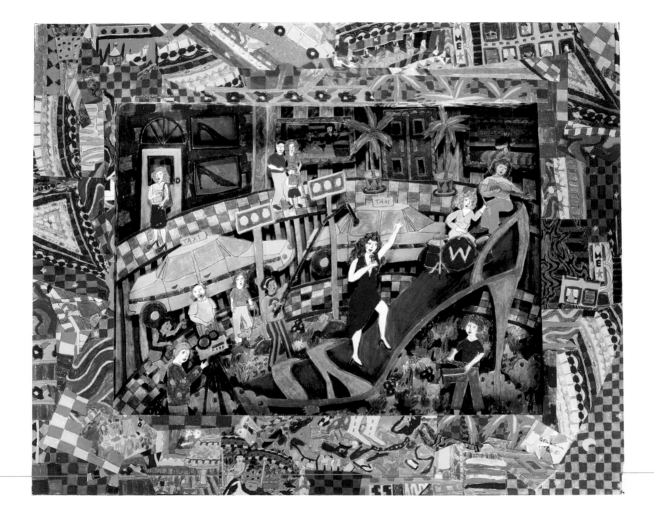

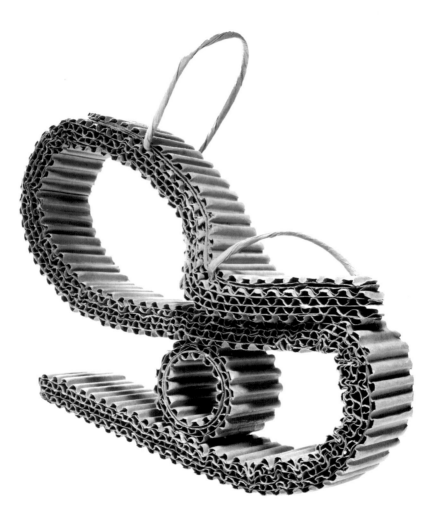

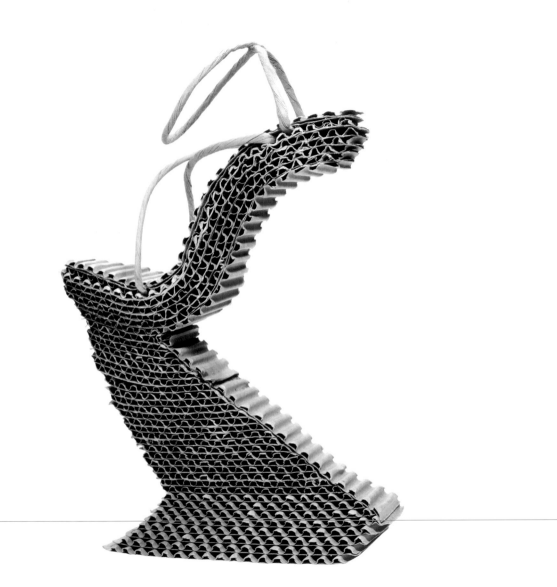

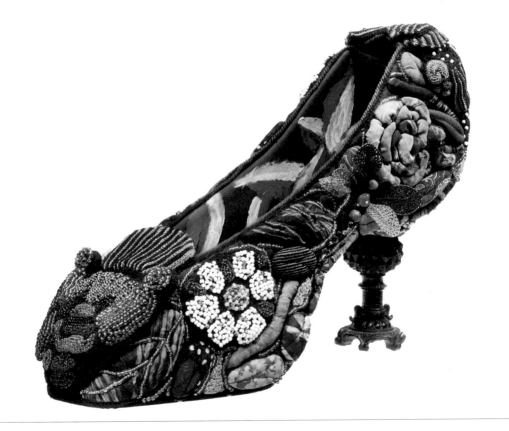

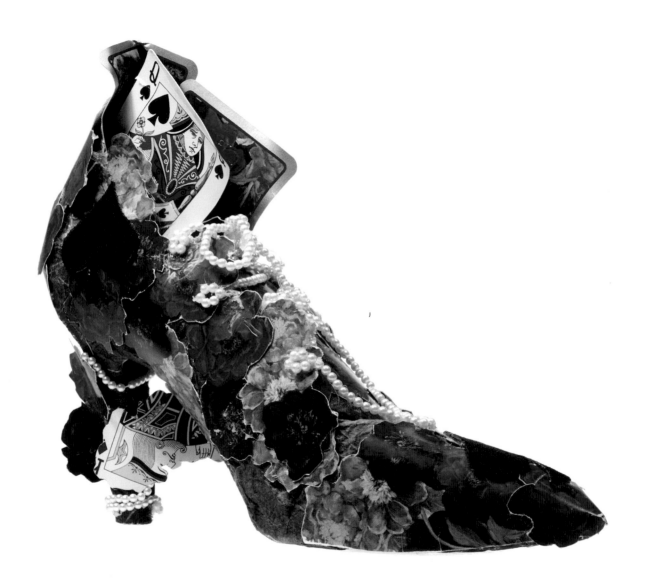

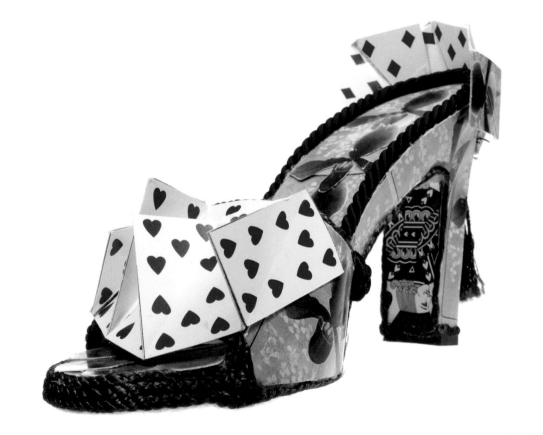

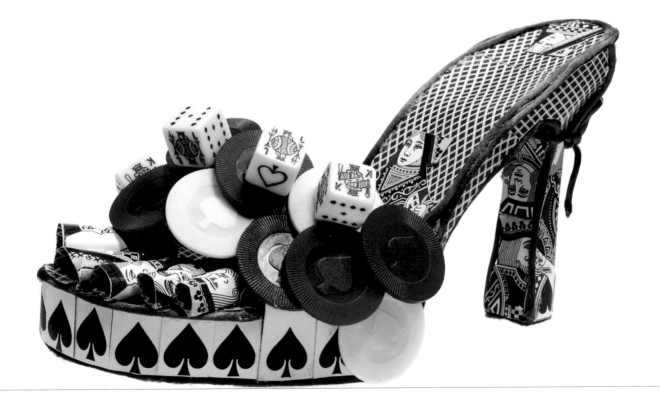

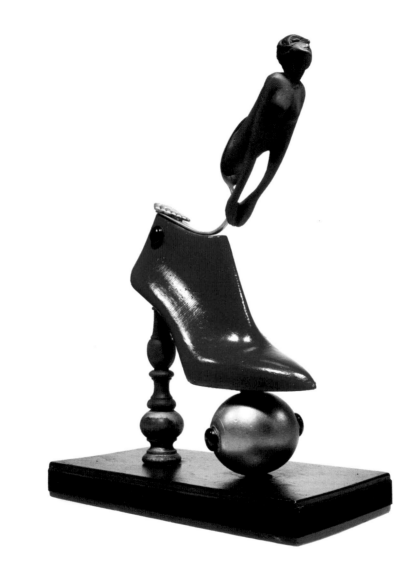

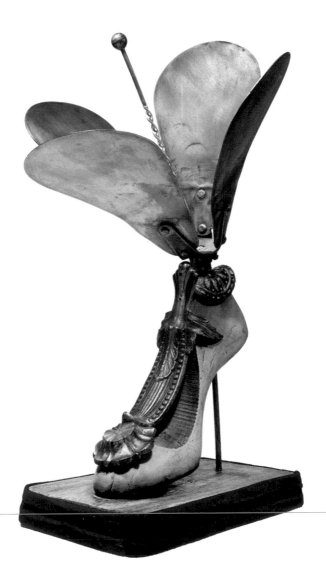

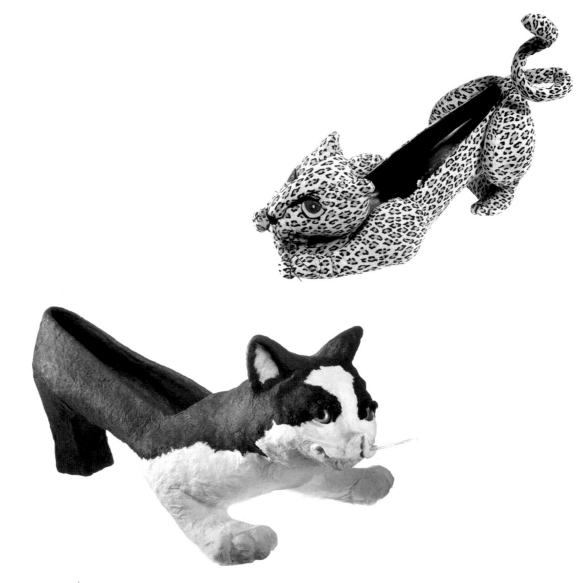

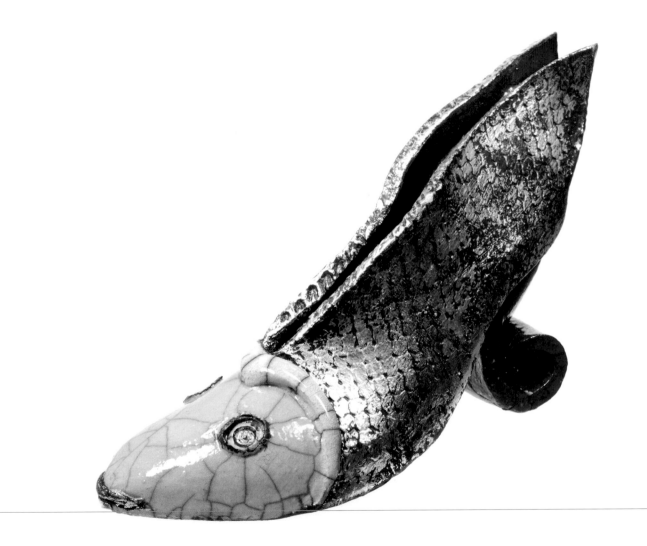

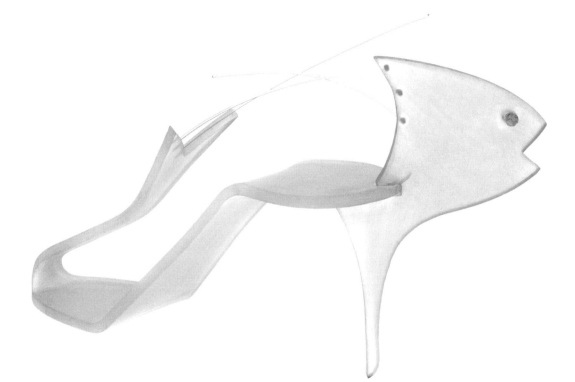

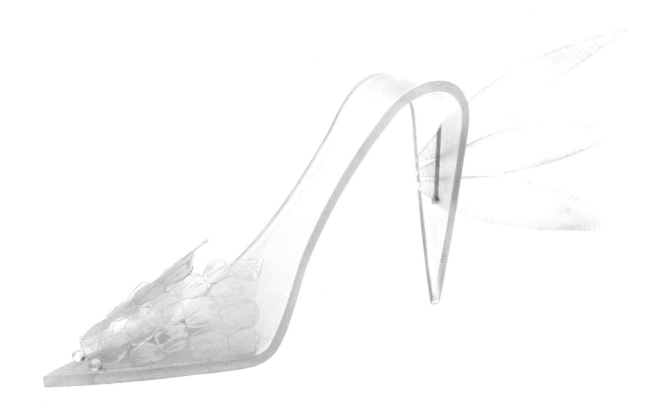

FINS AND SCALES | 119

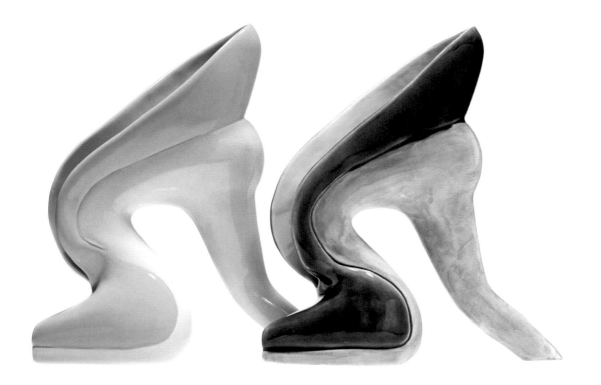

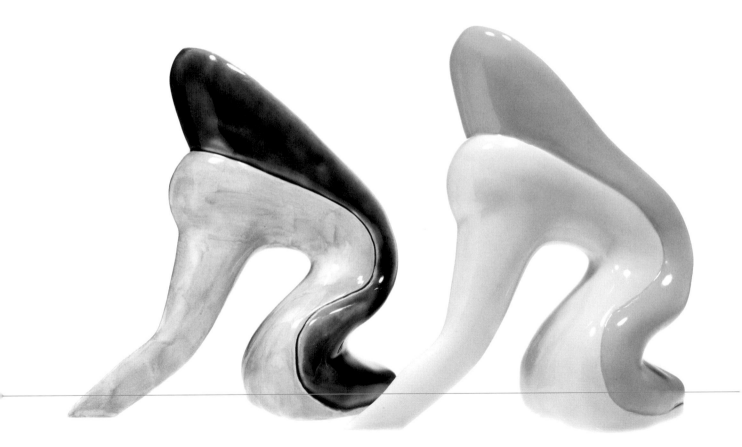

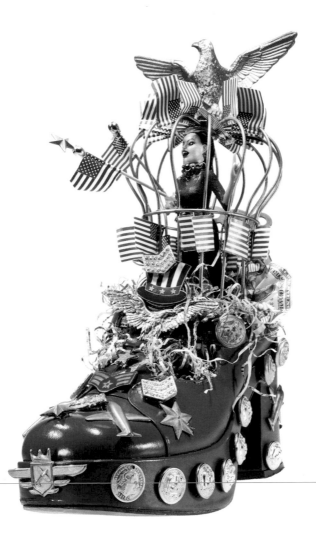

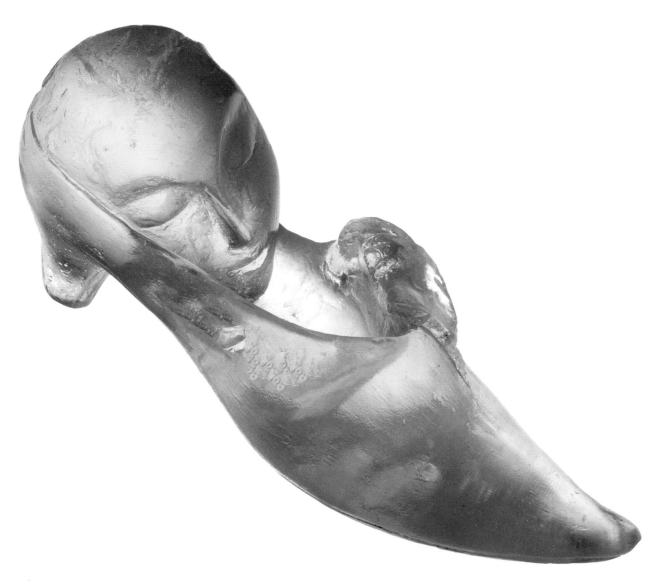

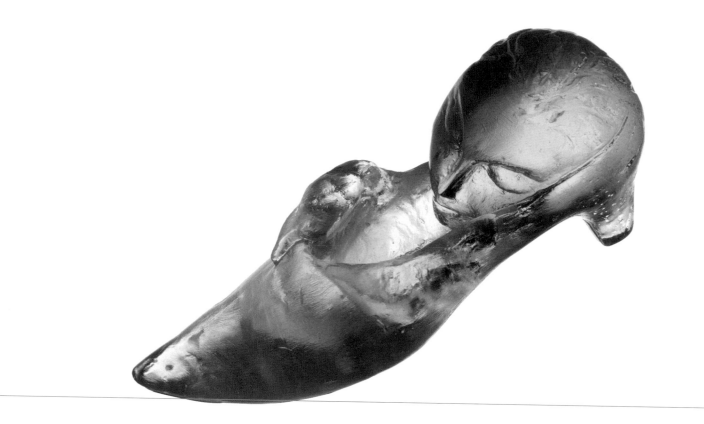

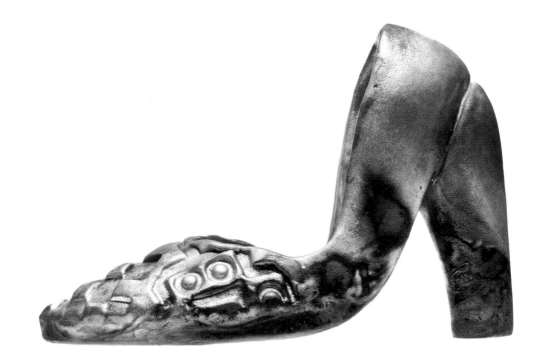

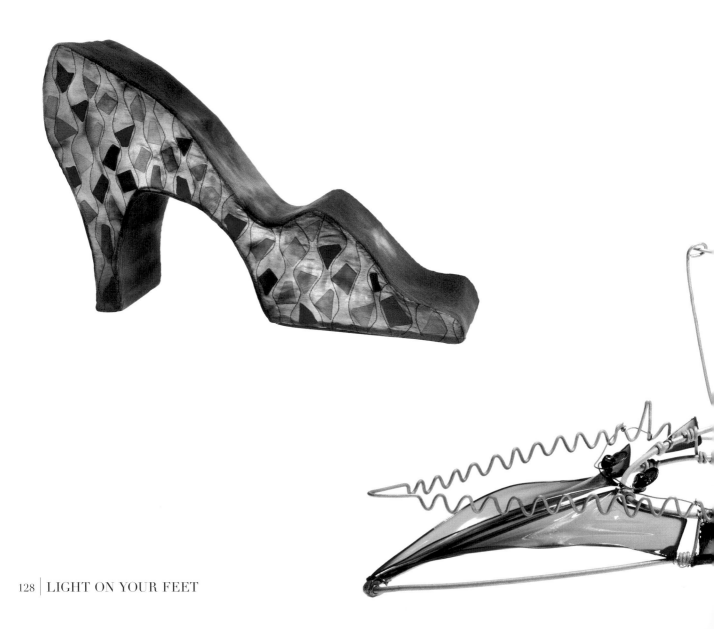

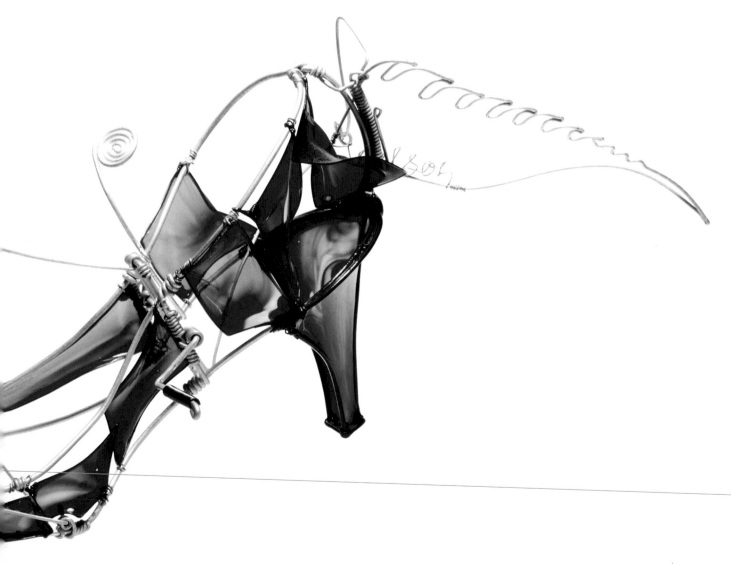

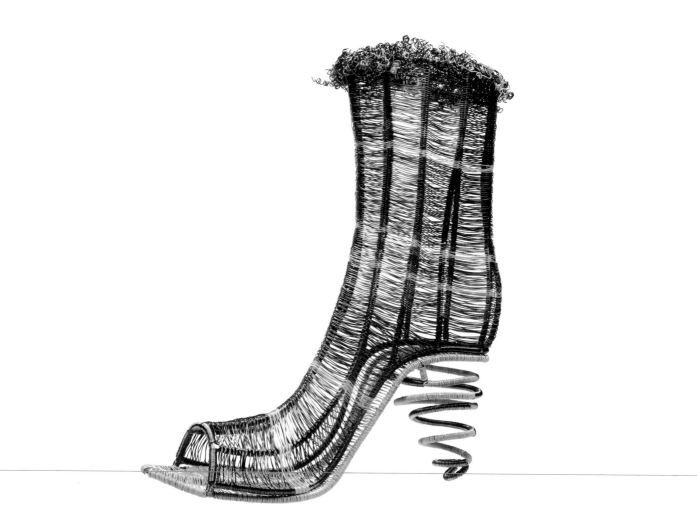

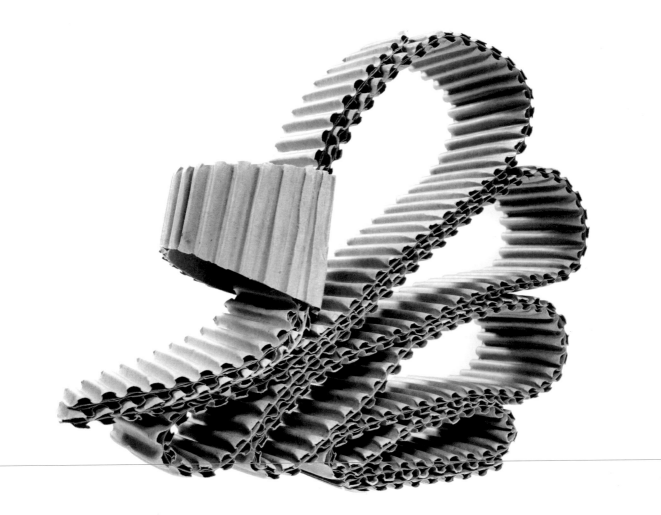

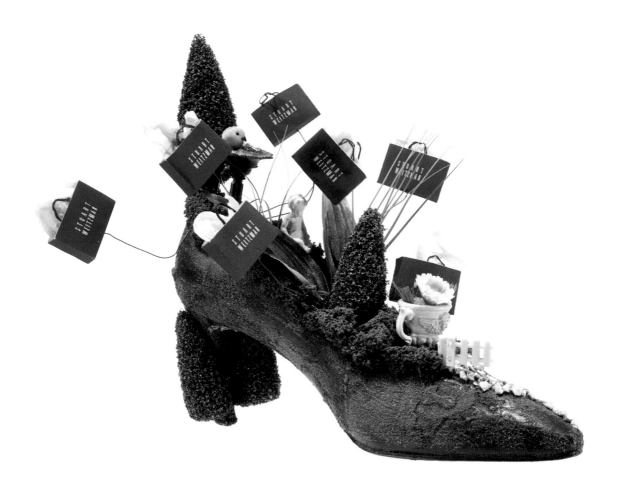

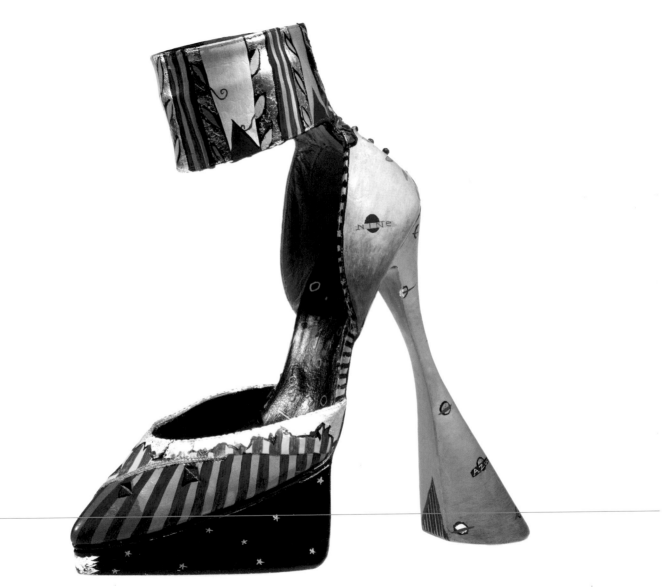

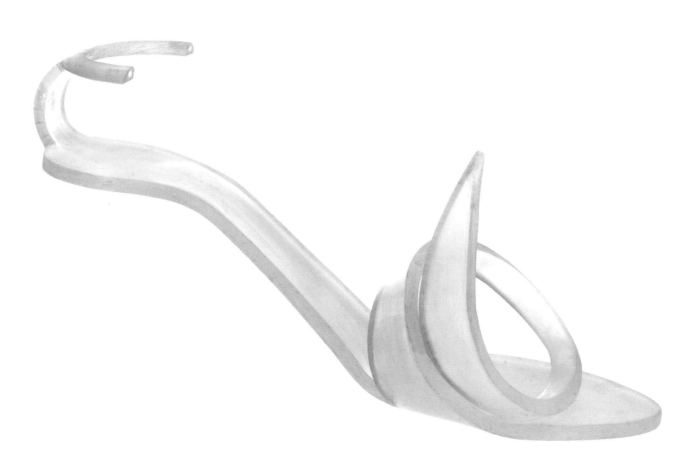

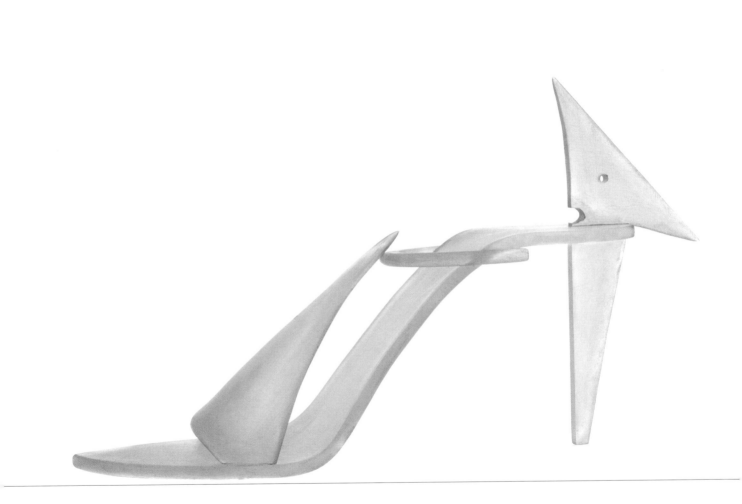

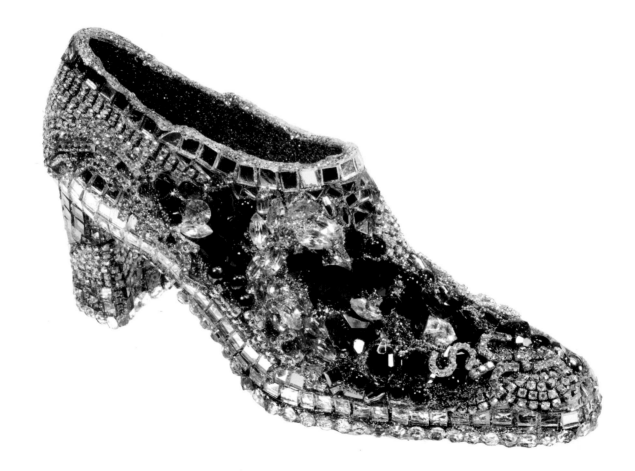

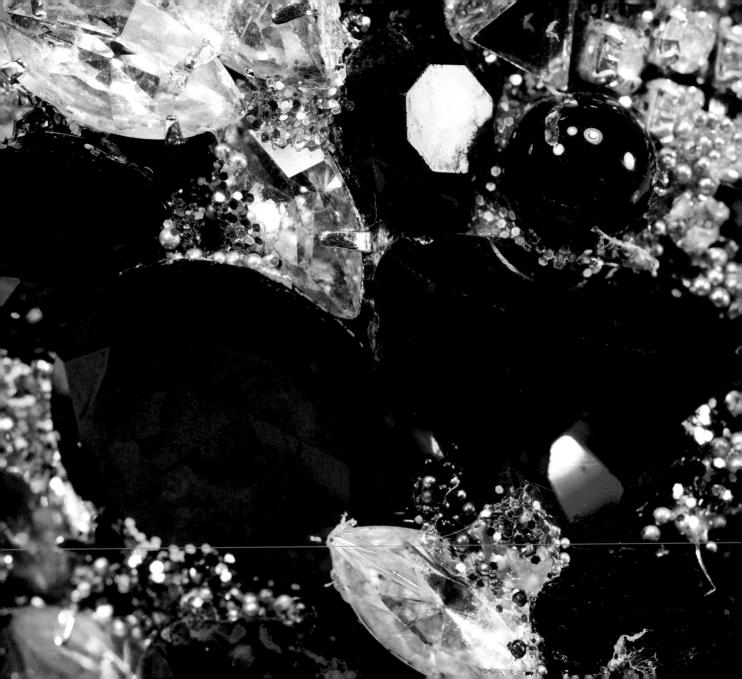

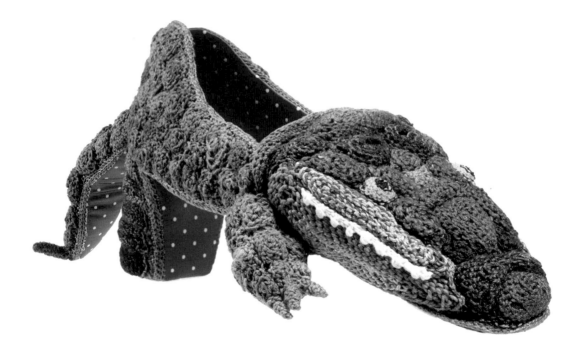

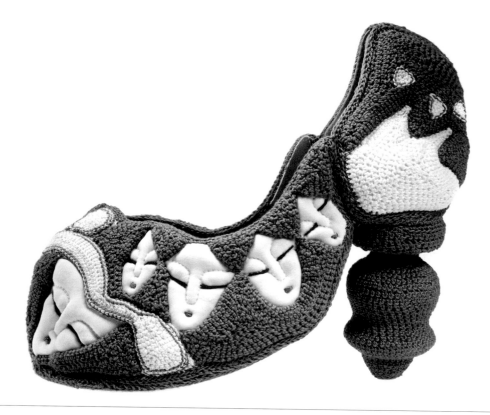

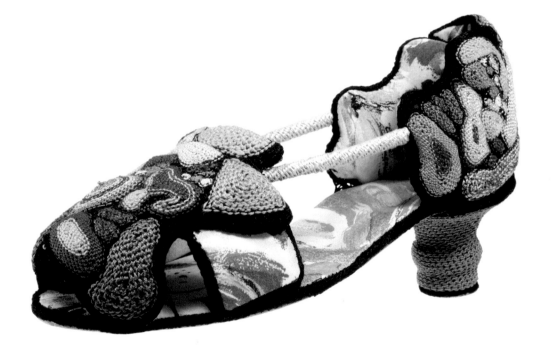

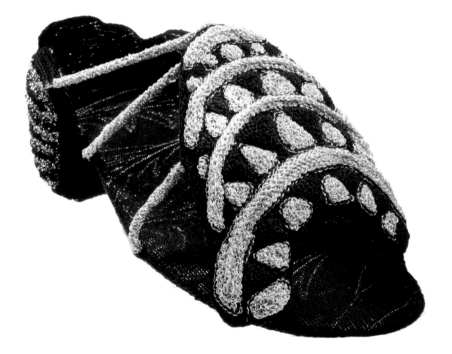

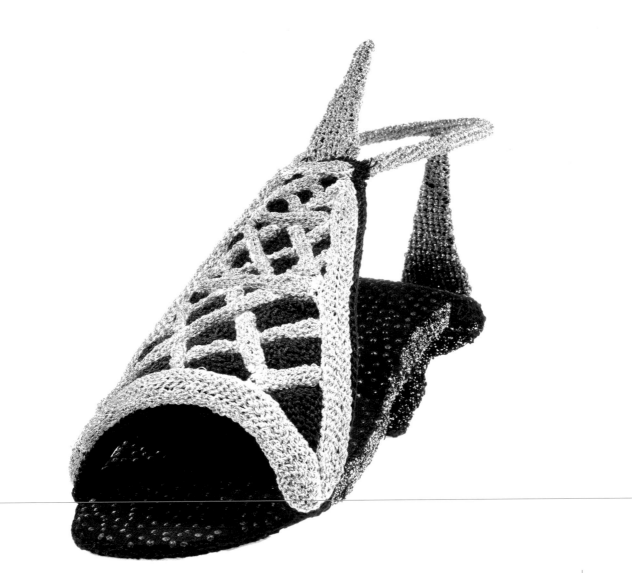

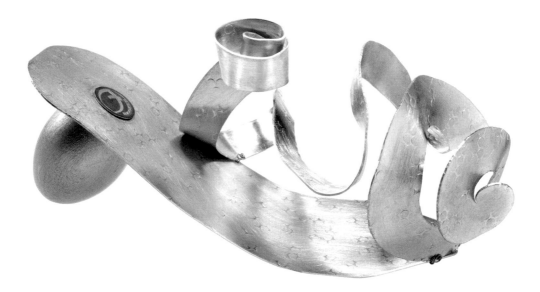

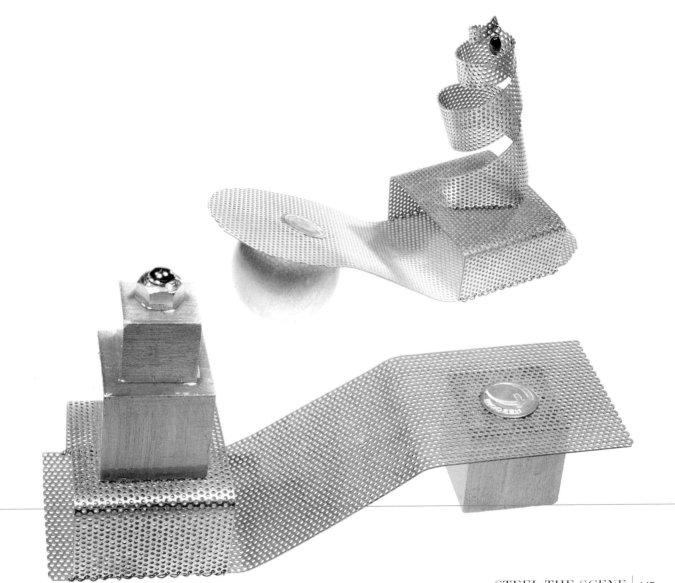

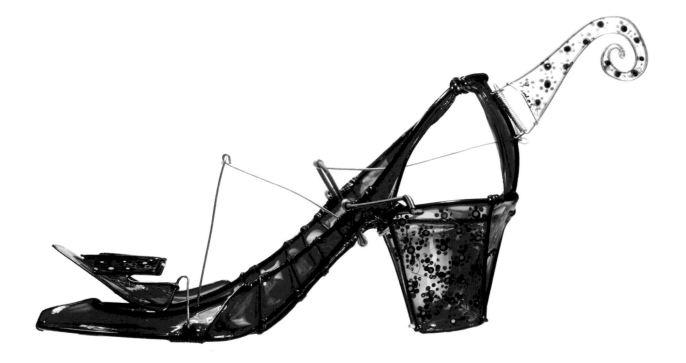

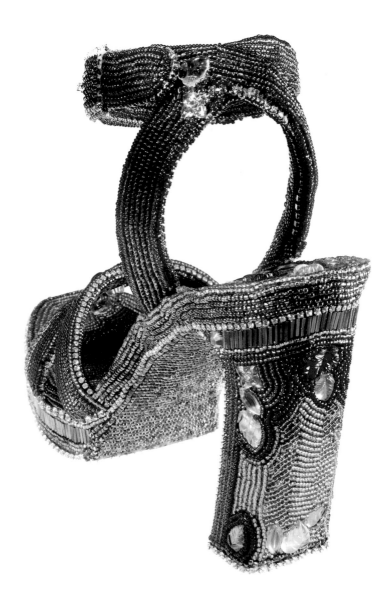

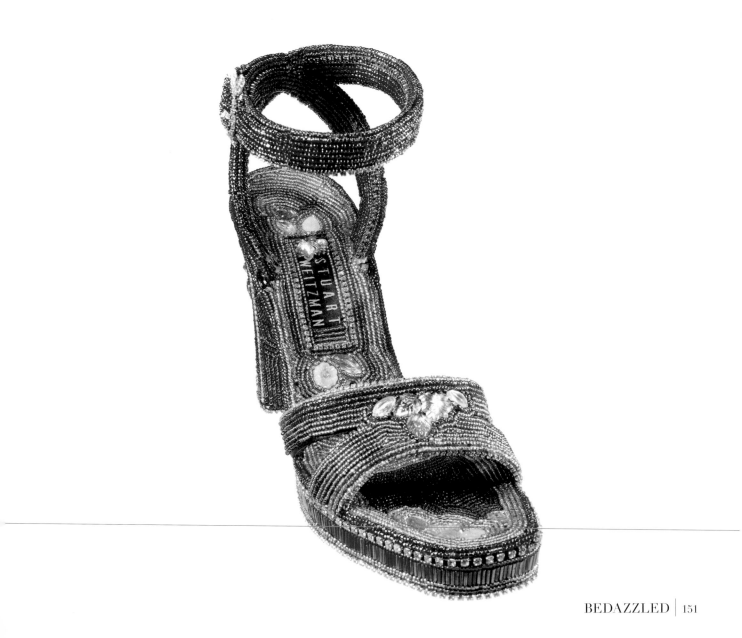

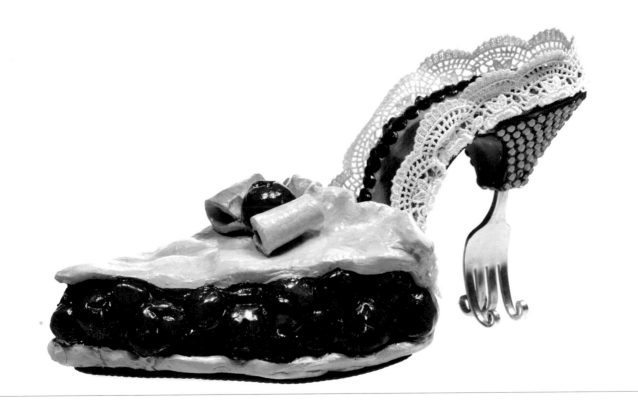

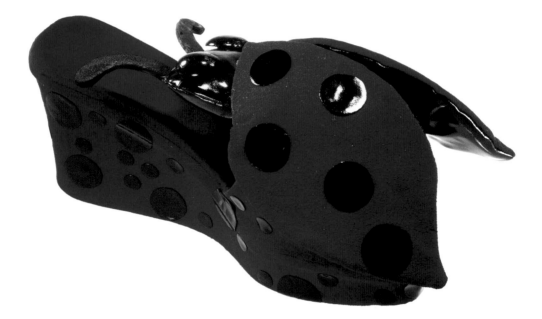

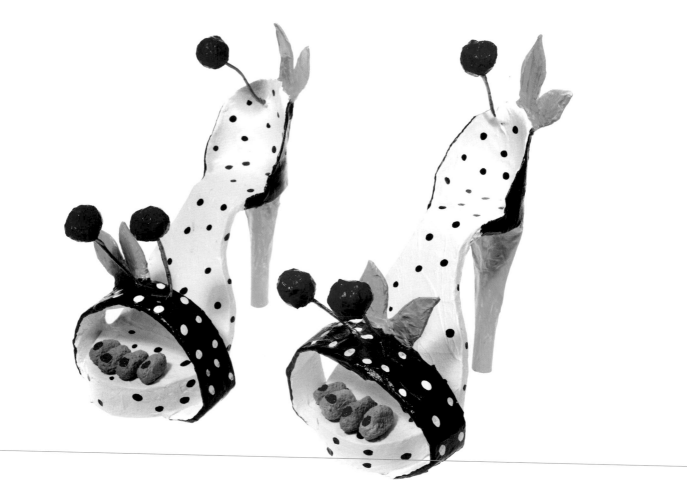

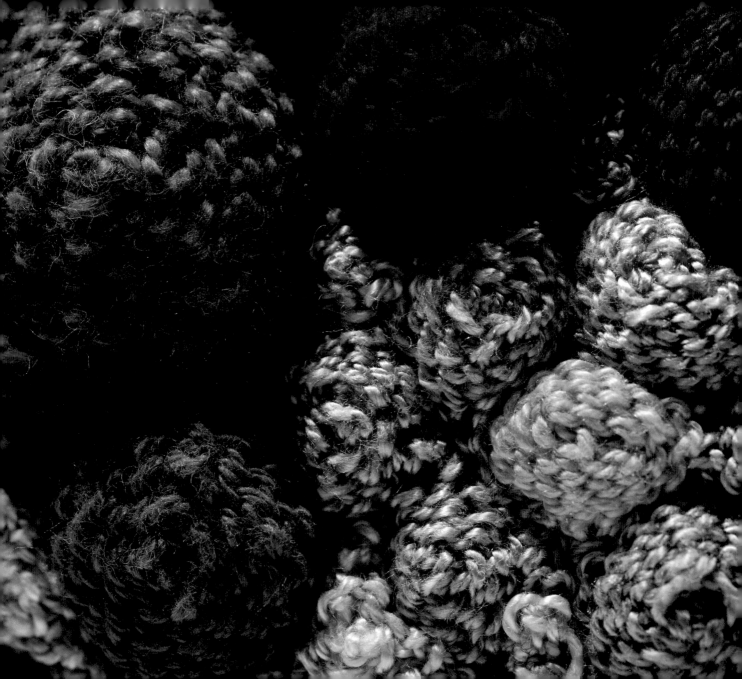

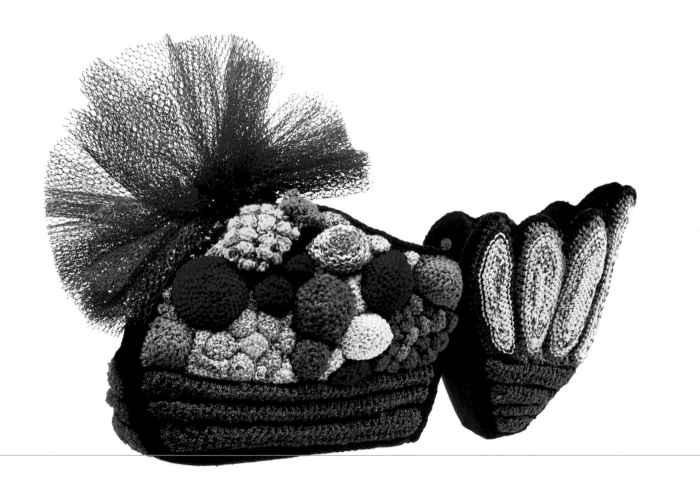

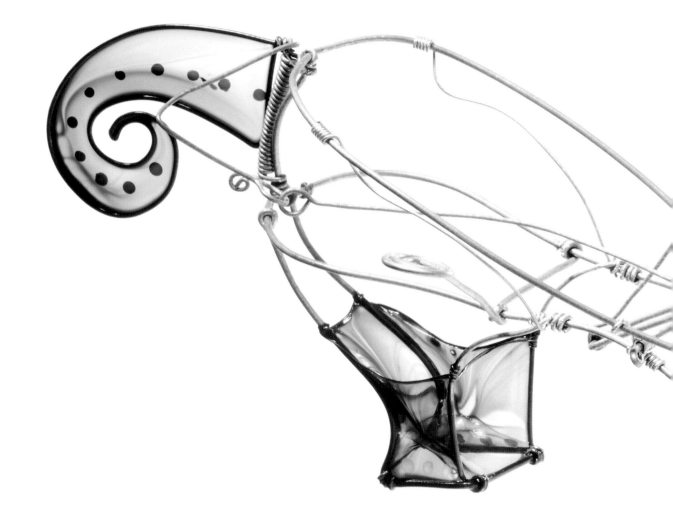

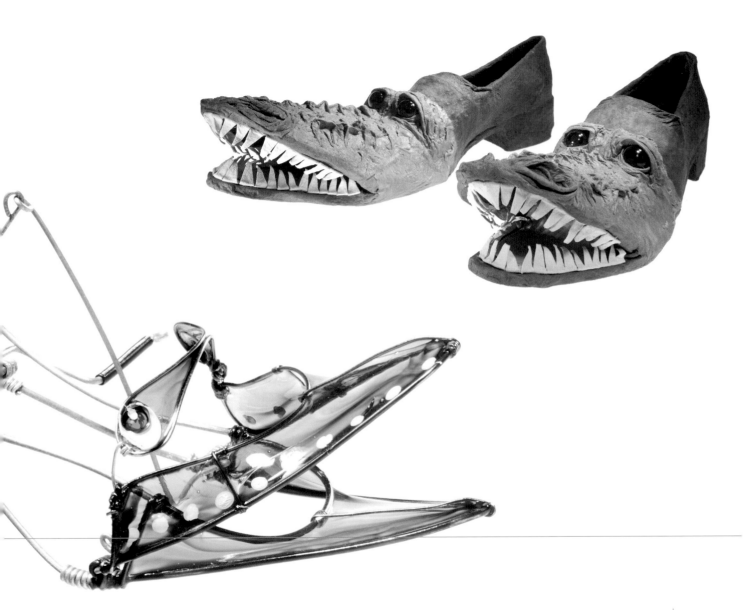

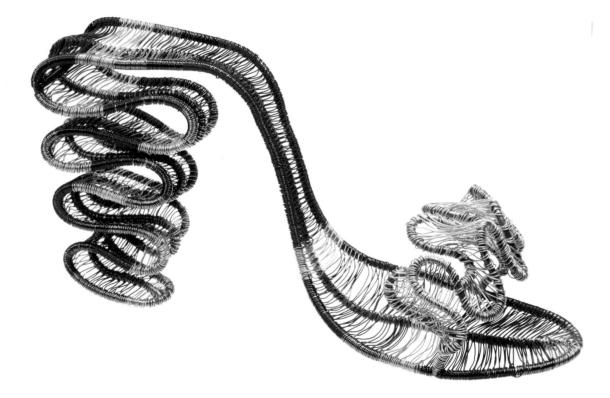

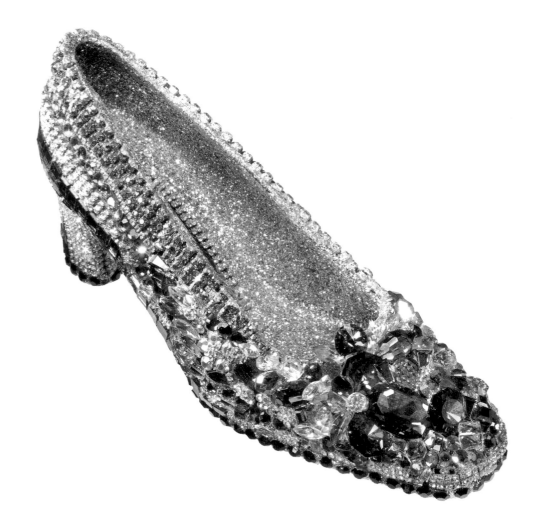

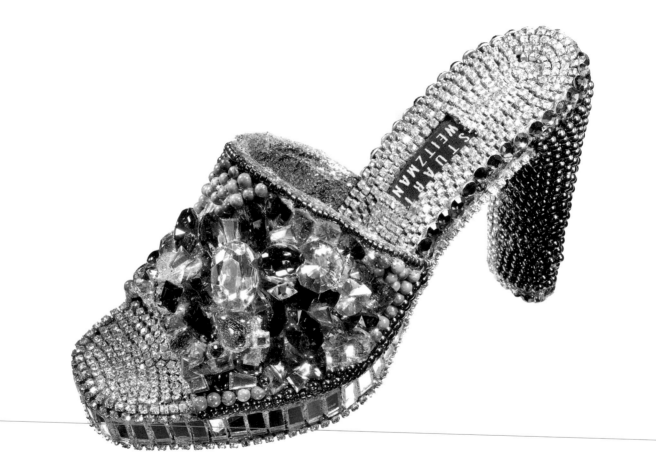

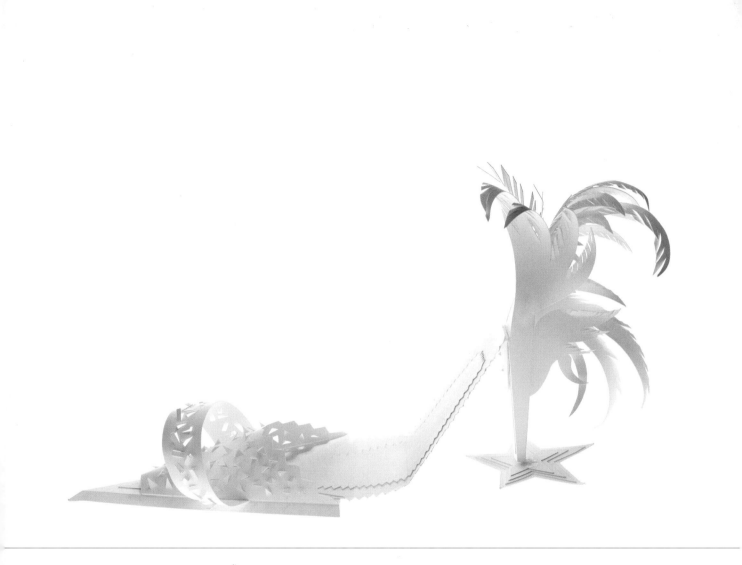

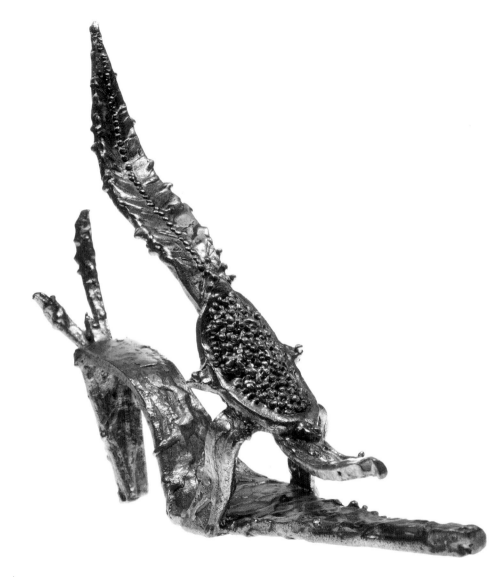

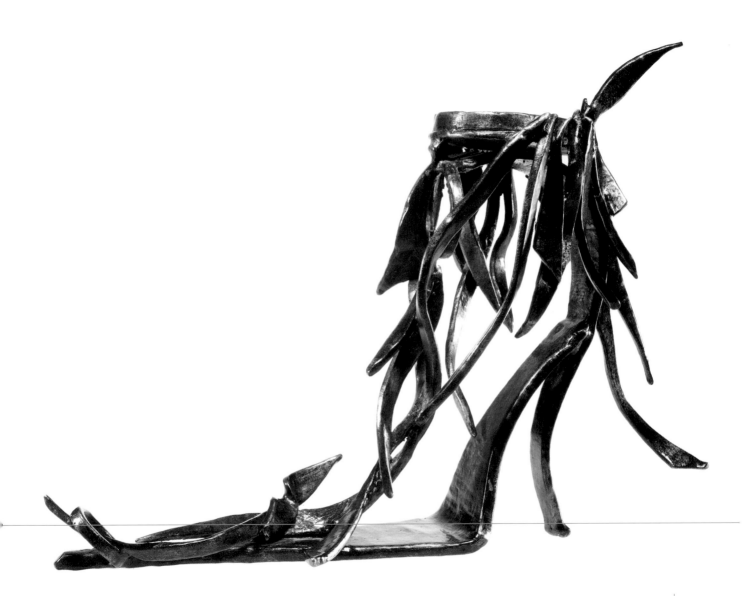

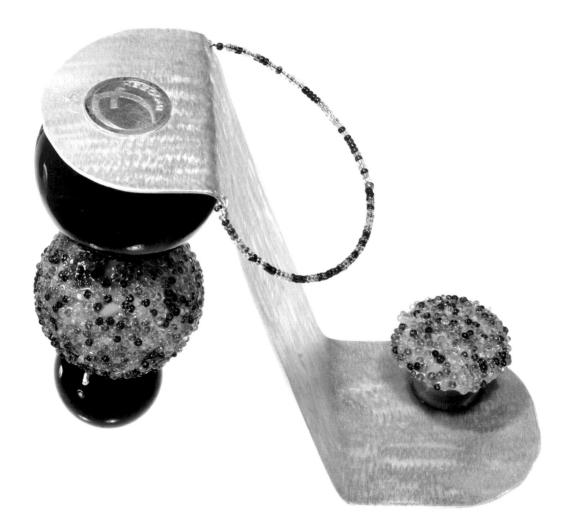

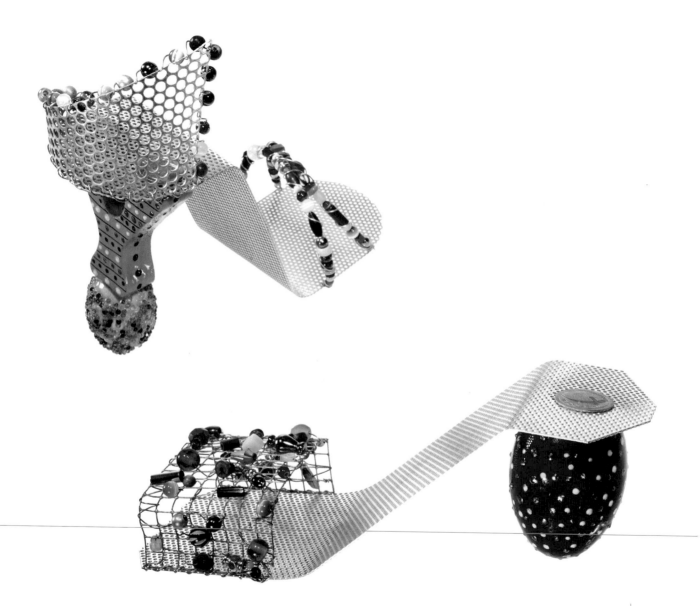

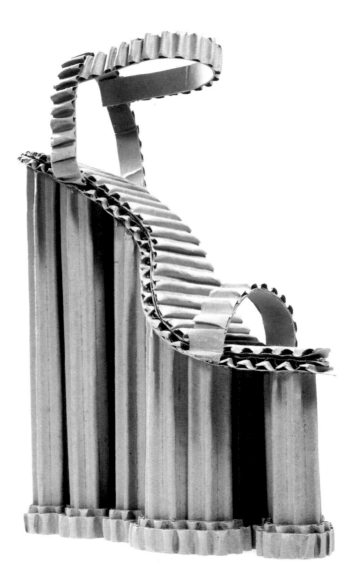

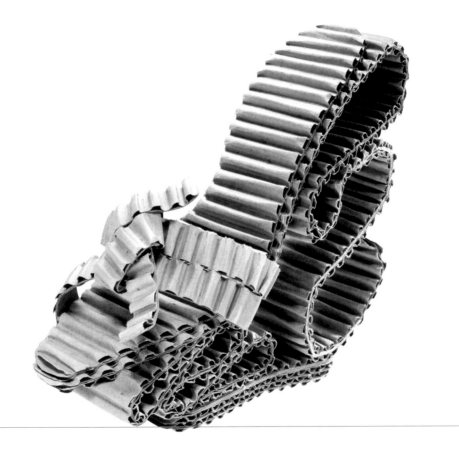

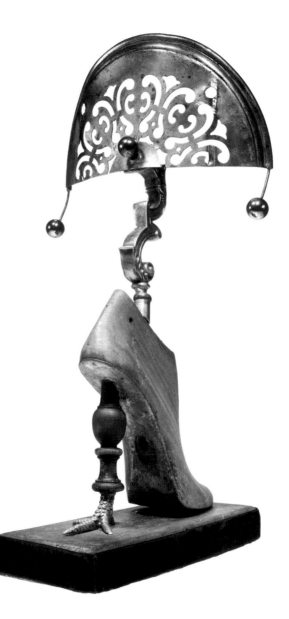

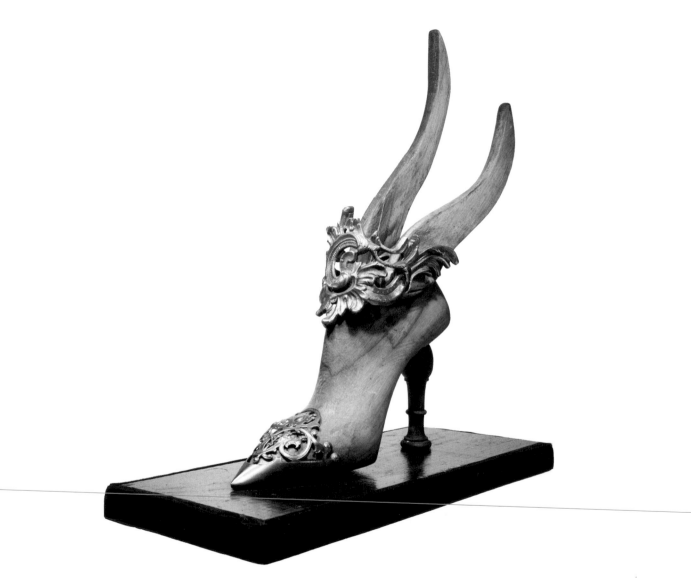

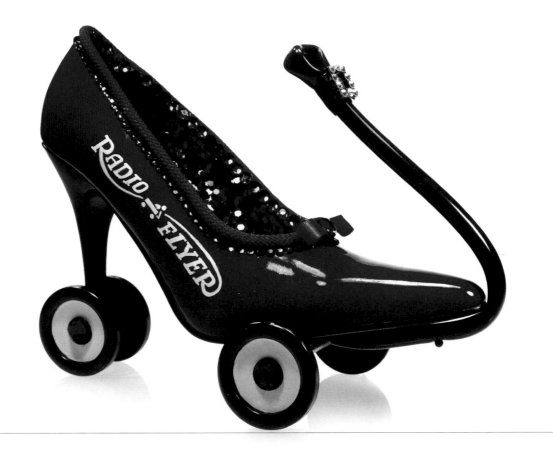

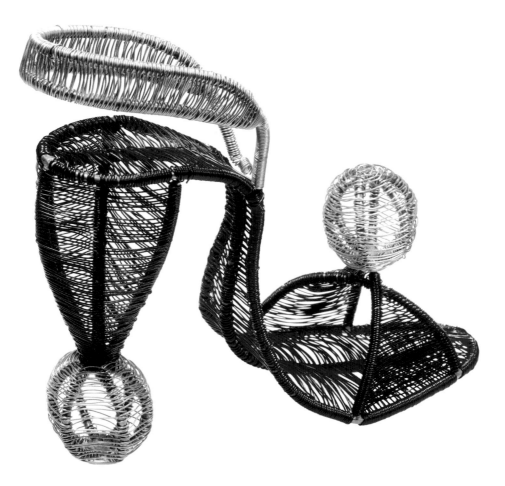

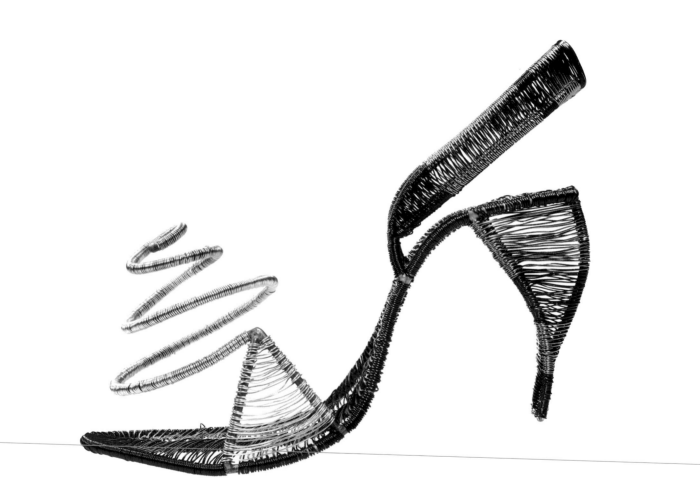

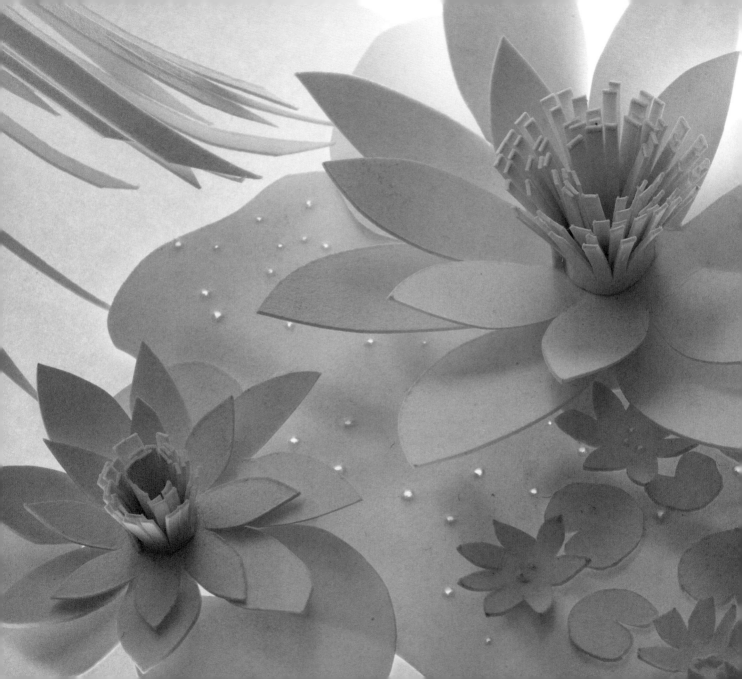

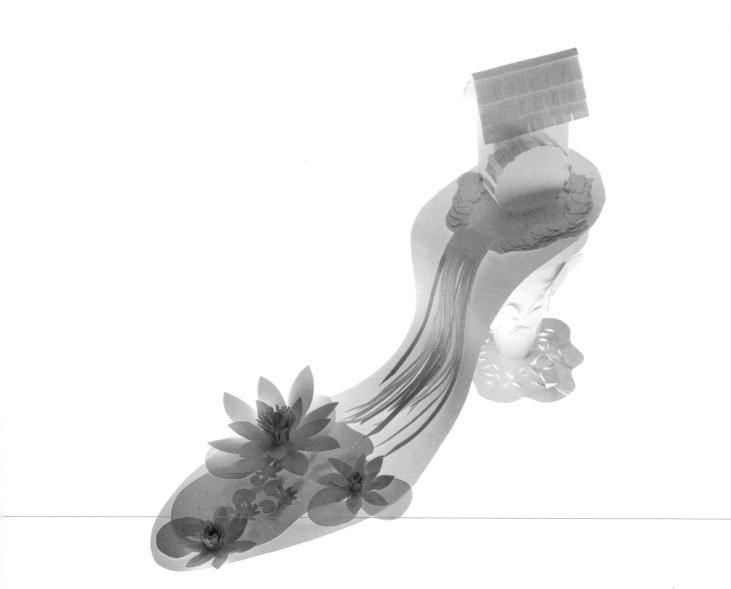

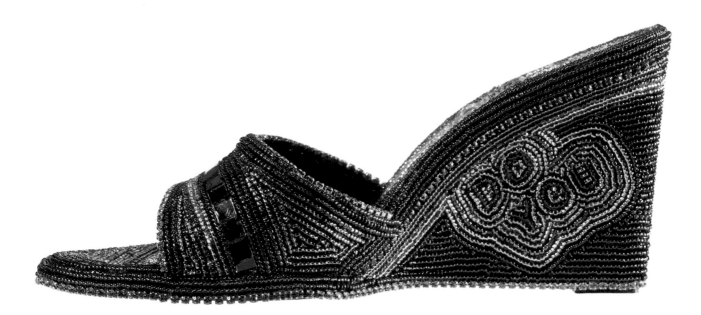

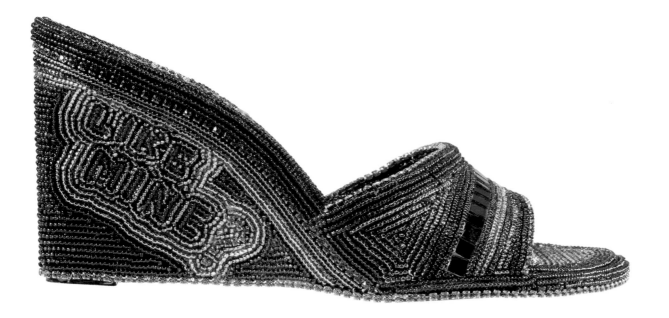

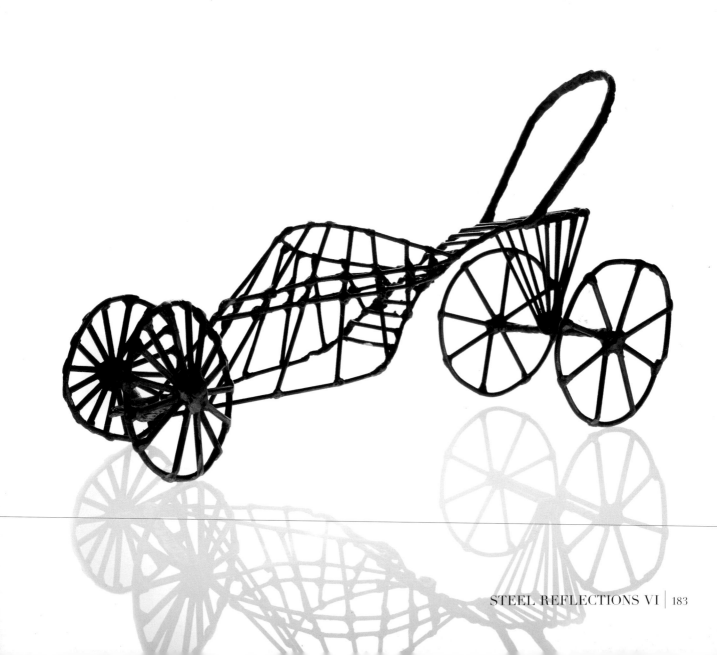

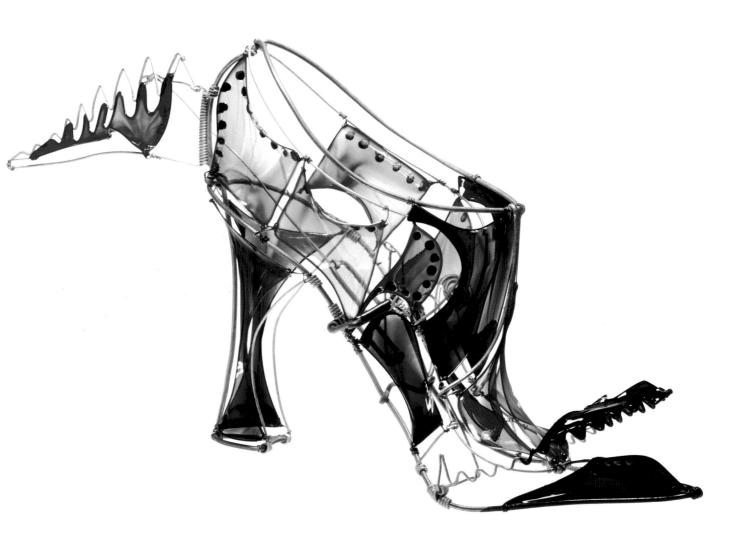

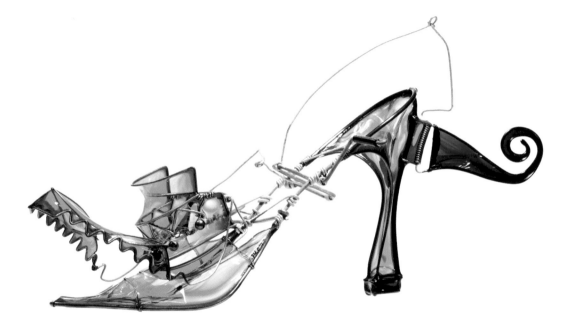

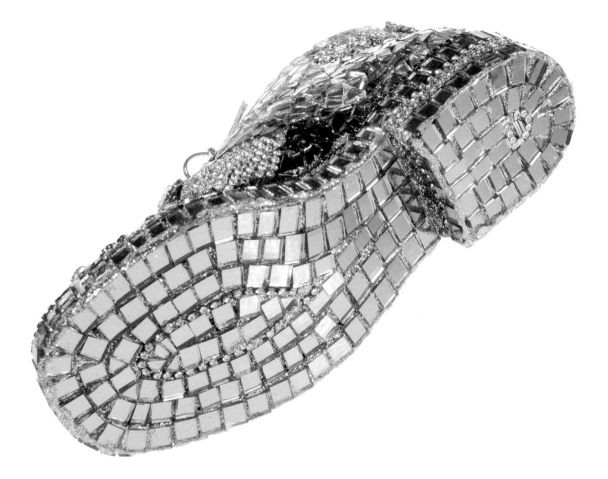

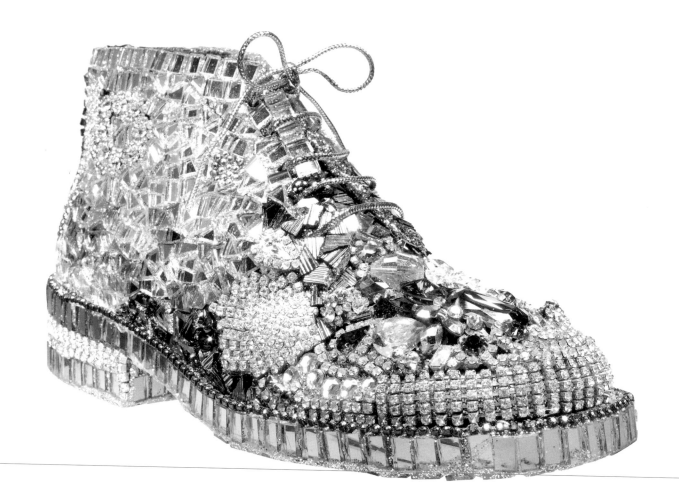

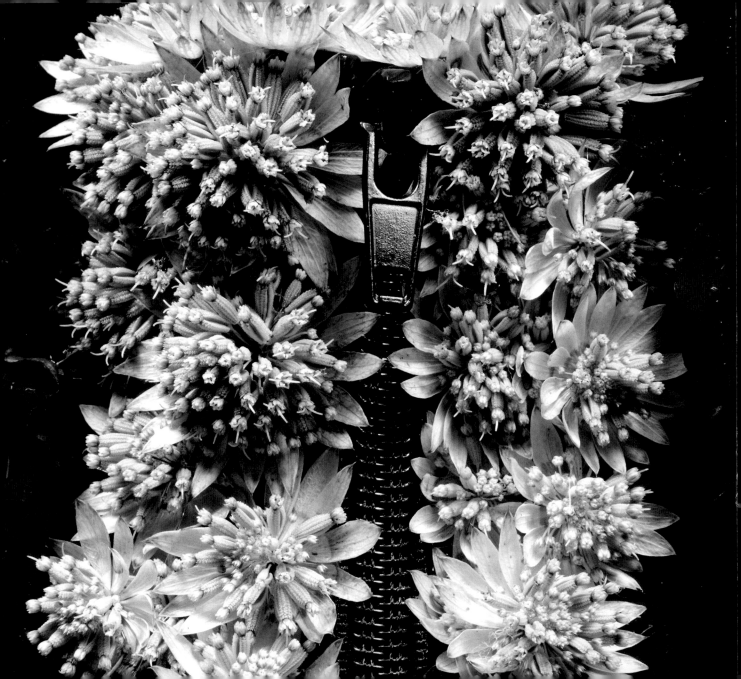

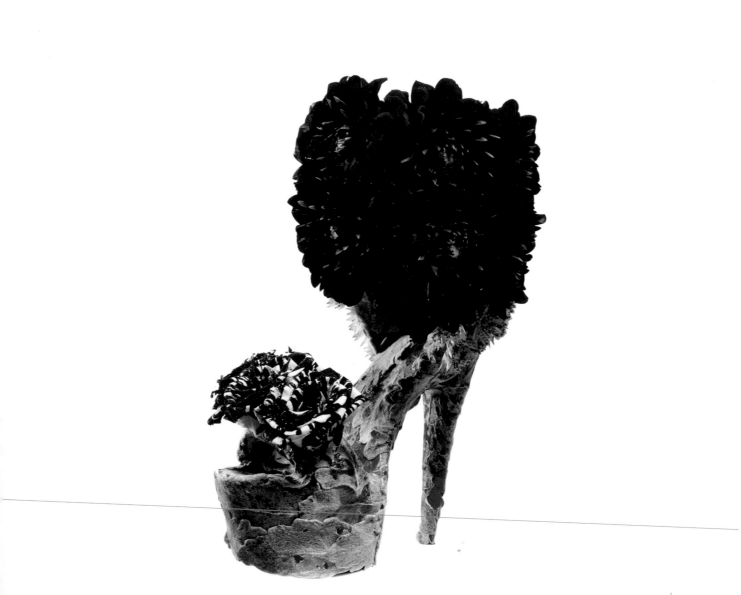

ABOUT THE ARTISTS

JOANNE BEDIENT

Joanne's pieces are constructed of handmade, raku-fired clay. A resident of Fort Myers, Florida, she has shown her work in galleries and museums throughout the United States. www.jbedient.com.

90

90

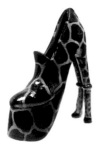

91

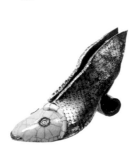

117

NINA BENTLEY

Nina's pieces are constructed of mixed media and found objects. She has exhibited her work, which tends to be conceptual in nature and focused on social issues, for more than forty years. In 2004, she was the featured artist for Barneys New York in a show called *Art Meets Fashion*. Her large sculpture *A Corporate Wife Service Award Bracelet* is in the permanent collection of the New Britain Museum of American Art in New Britain, Connecticut. She resides in Westport, Connecticut, and New York City. www.ninabentley.com.

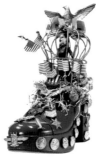

123

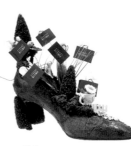

134

FIROOZEH BOWDEN

Firoozeh's pieces are constructed of perforated steel, metal mesh, copper, nickel silver, brass, beads, semiprecious stones, wood, rubber, glass, and paint. Since 1993, Firoozeh has combined her fashion design and metalworking talents to create sculptural accessories that both set and capture the latest trends in contemporary style. She currently works from her studio near Atlanta, Georgia. www.firoozehinc.com.

JANE CARROLL

Jane constructed these three shoes from pink calla lilies with ranunculus, hydrangea florets, and lamb's ear; blue scabiosa with hydrangea florets and galax leaves; and burgundy dahlias with hocus pocus roses and dusty miller leaves. A floral designer and event planner, she has been featured on ABC's *The View* and *The Oprah Winfrey Show*, as well as in many national publications. Her flower and gift shop, Jane on Main, is located in Pearl River, New York. www.janecarroll.com.

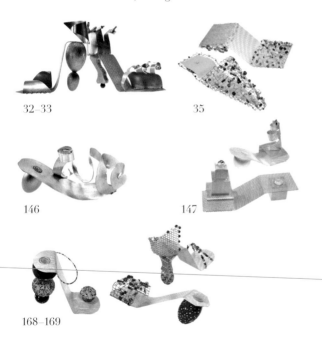

32–33

35

146

147

168–169

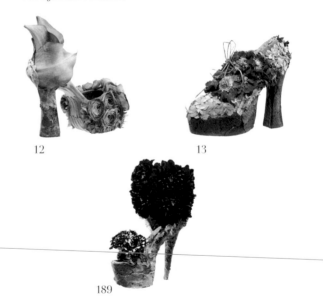

12

13

189

CHARLENE CLARK

Charlene's pieces are constructed of paper, wheat paste, water, wood, and wire. A Baltimore native, she is a self-taught sculptor and painter. Her lifelong collection of ephemera and objects serves as an inspiration for her work, which reflects a highly personal amalgam of imagination and childhood memory. www.charleneclarkstudio.com.

WENDY COSTA

This piece is constructed of resin, silver leaf, acrylic, and wood. Wendy's eponymous product lines feature her colorful artwork in fashion accessories and jewelry, gift items for the home, posters, books, paintings, and sculpture. She has also been commissioned to design greeting cards, posters, and retail interiors and windows for various clients, from Ben & Jerry's to Neiman Marcus. She lives and works in Starkville, New York, in a restored gothic church and parsonage. www.wendycosta.com.

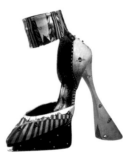

135

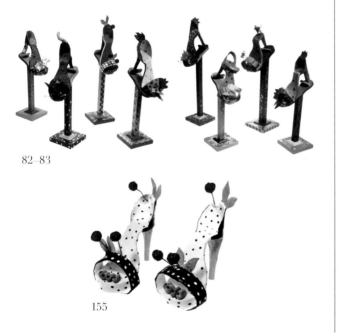

82–83

155

DAN CROWLEY

Dan's pieces are constructed of polymer clay and paint. A sculptor in that medium for more than twenty years, he has created characters and puppets that have appeared in the windows of Tiffany & Co. and on HGTV's *That's Clever!* www.dancrowleystudio.com.

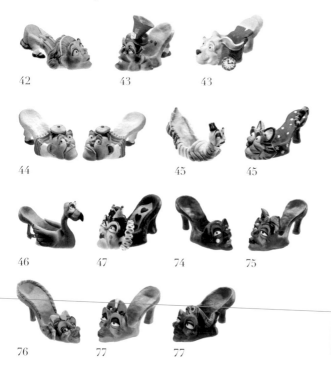

42　　　43　　　43

44　　　45　　　45

46　　47　　74　　75

76　　77　　77

GRAHAM SCARBOROUGH DAVIDSON
(in memoriam)

Graham's shoes were created with colored pencil on paper. A self-taught artist from Abilene, Texas, who lived in Vermont, Graham depicted people and places in her work with a humorous and sometimes graphic view of the quotidian. Her drawings evolved into three-dimensional shadow boxes that sprang to life when they were collaged, layered, and enclosed behind glass. Her work remains a vivid reminder of her warm and witty personality. Gallery: Fiddlehead at Four Corners. director@fiddleheadvermont.com.

104　　　　105

TIMOTHY FORTUNA

Tim's shoes were created from standard and floral-themed playing cards, mah-jongg tiles, and poker chips. Tim started working in visual merchandising at the age of sixteen in Albany, New York. He moved to New York City in 1968, and by 1980 he was running his own design business. In 2000, he started working with Jane Weitzman to further develop the art shoe program in the Stuart Weitzman windows. He resides in Vicenza, Italy. www.timothyfortunadesigns.com.

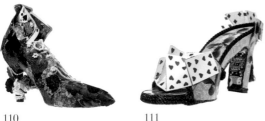

110 111

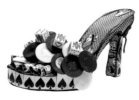

113

VALERY GUIGNON

Valery's piece is a lamp constructed of steel wire, dyed silk, tulle, and tumbled glass. Valery majored in industrial design at Pratt Institute and creates clothing and accessories as well as lamps. Her goal has always been to combine art and practicality. She resides in Texas. www.guignon.com.

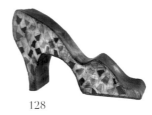

128

JOYCE HARRIS

Joyce's work was created from repurposed wood, silk, cork, shells, and prairie grass. A native Chicagoan, she studied at the Art Institute and at the Evanston Art Center in Evanston, Illinois. joycekharris2003@gmail.com.

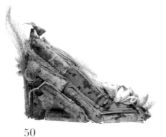

50

ANN JOHNSON

Ann's shoes were created from abaca, cotton rag, and transient dyes. She is an award-winning artist and entrepreneur who made her first artistic splash in 1964, when she took lint from her dryer and began making a sculptural line of paper clocks, two of which are displayed in the East Wing of the White House. Her business, F.B. Fogg, was based in Muncie, Indiana. After a long career in the arts, she is now in semi-retirement and divides her time between helping young artists improve their skills and painting on the banks of Indiana's White River. www.houseslipper.blogspot.com.

EVELYN KAPLAN

Evelyn's shoes were constructed from vintage dishes, china, and jewelry; porcelain figurines and flowers; stained glass; tiles; mirror pieces; and ceramic knickknacks. Evelyn's passion for collecting treasures from the past and her love of beautiful china led the Philadelphia native to pursue the mosaic art form *pique assiette*. She started her own company, and her work in this mosaic style can now be found worldwide. www.inspirationsinmosaic.com.

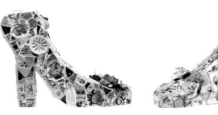

86 86

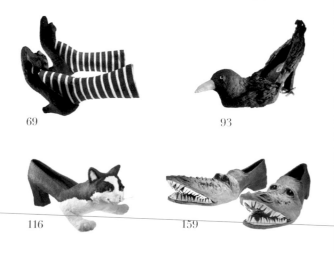

69 93

116 159

JOAN KLIMO
(in memoriam)

Joan worked in fabric and mixed media. A North Carolina native, she was an art director at Condé Nast publications in the 1960s and an editor at *Jardin des Modes* magazine in Paris. She also designed shoes for Christian Dior. She began designing soft sculpture in the late 1990s; her work was shown and sold at the Whitney Museum of American Art in New York City.

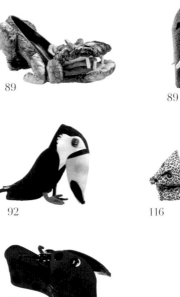

89

89

92

116

154

LINDA LEVITON

Linda works in coated and bare copper wire. Since setting up her sculpture studio in 1993, she has exhibited her art nationally and internationally, working with galleries, art consultants, architects, and designers. She has developed public art projects, installations, and wall sculptures, both large and small. She lives and works in Lewis Center, Ohio. www.lindaleviton.com.

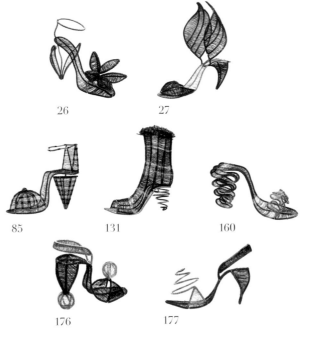

26

27

85

131

160

176

177

KATHERINE MATHISEN

Katherine's work is hand-sculpted, raku-fired clay. She has collaborated with many masters in contemporary sculpture and taught ceramics for more than fifteen years. She exhibits her award-winning ceramic sculpture in galleries and at art festivals throughout the United States. Her pieces are in both public and private collections worldwide. www.katherinemathisen.com.

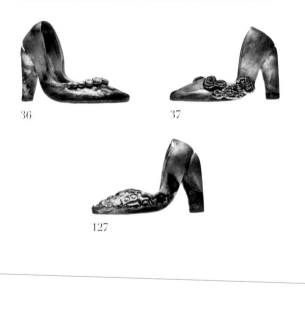

36 37

127

JOAN McCLUTCHY DE VIDARGAS

Joan works in bronze. She combines a lifelong obsession with shoes and twenty years of experience in the fashion industry to create her extraordinary bronze footwear. She lives and works in San Miguel de Allende, Mexico, where she sculpts in the lost-wax method, creating one-of-a-kind pieces that marry this ancient art with style and wit. joanvidargas@gmail.com.

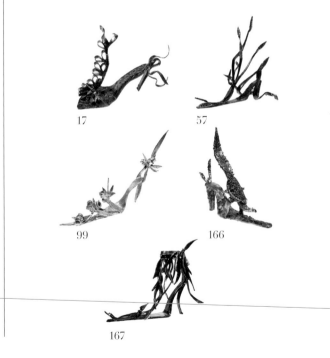

17 57

99 166

167

DANIELE POLLITZ

Daniele's pieces are crafted of resin. Inspired by how clear resin mimics glass, she started experimenting with the material in 1996. In 1998, the G&P Foundation for Cancer Research honored Daniele with the commission to sculpt the Angel of Hope award, which was presented to President Bill Clinton. She currently divides her time between New York City, Paris, and Morocco. divapapou@gmail.com.

54

55

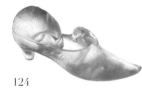
124

125

KEVIN RADU

Kevin's work is constructed of steel and found industrial objects. Self-taught, Kevin works in many media. He made a 9/11 memorial piece for the Chrysler headquarters in Detroit, Michigan, and has taught illustration at the Parsons School of Design. He shows his art primarily in galleries in New York City, where he has lived for the past thirty years. universe@dishmail.net.

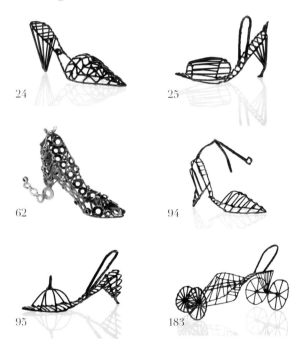
24

25

62

94

95

183

IDA RAK

Ida's work is constructed of handmade paper and gouache. She studied textile design at Shenkar College of Engineering and Design in Tel Aviv. Renowned for her hand-painted paper sculptures, which have functioned as accessory items on New York and London runways, her clients include Tiffany & Co. and Gottex. www.ida-rak.com.

53

65

IRENE C. REED

Irene works in cotton and metallic thread. Self-taught, she has been crocheting for more than forty years. Her work is in the permanent collection of the Renwick Gallery in Washington, DC, and the textile collection of the Wadsworth Atheneum in Hartford, Connecticut. Her work was also included in two traveling exhibitions of the Smithsonian Institution, which toured for more than five years worldwide. www.paradisecityarts.com.

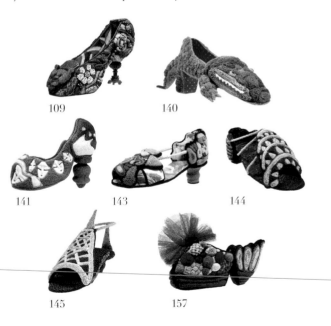

109

140

141

143

144

145

157

ANTHONY ROSIELLO

Anthony uses Arches hot press watercolor paper and archival glue to create his paper sculptures. Born in New York City, Anthony studied advertising design at Pratt Institute and worked in advertising for twenty years. He has a studio in Southern California. desertarms@dc.rr.com.

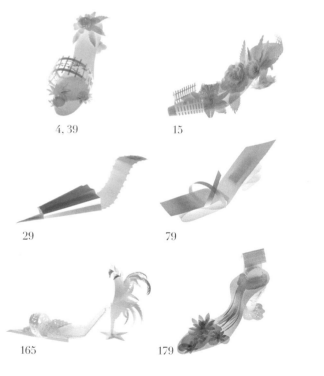

4, 39 15

29 79

165 179

ROBIN ROTH-MURPHY

Robin's mixed-media shoes incorporate found metal wrapped in silk and synthetic textured fibers; fabric; torn fabric woven into mesh canvas; new and vintage buttons, zippers, spools of thread, and embroidery needles; paint; wire; jewelry collected from estate sales; and glue. She is a graduate of the Louisville School of Art, Art Institute of Atlanta, and Atlanta College of Art. Although her grandfather was the poet and painter Nahum Tschacbasov, whose work both haunted and enchanted her, it was her mother's homespun artistry displayed in their house that inspired Robin to pursue a career as an artist. robinmurphy401@gmail.com.

 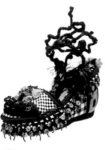

80 81

ROBERT STEELE

Robert works in corrugated cardboard. He studied at the École Nationale Supérieur des Arts Décoratifs in Paris and has a fashion and retail background. He lives and works in New York City.

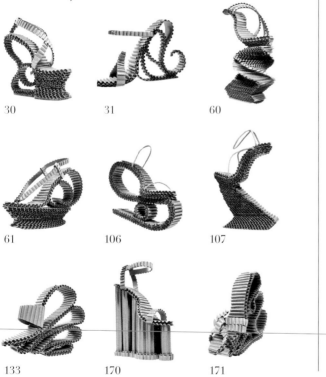

30 31 60

61 106 107

133 170 171

ROBERT TABOR

Robert's Tin Man and Cowardly Lion shoes are composed of polymer clay, acrylic, various fabrics and trims, crystals, and metal; the Scarecrow shoe: polymer clay, acrylic, various fabrics and trims, crystals, and straw; the Toto shoe: rubber, acrylic, and fabric; and the State Fair shoe: polymer clay, acrylic, plaster, fabric, and rhinestones. His taxis and wagon were created with acrylic, vinyl, various trims, and rhinestones. The Very Cherry shoe is crafted of polymer clay, acrylic, fabric, metal, and rhinestones, while Shoe Shower is made of acrylic, fabric, metal, and crystals. He has training in graphics, costume design, and window display. www.roberttabor.com.

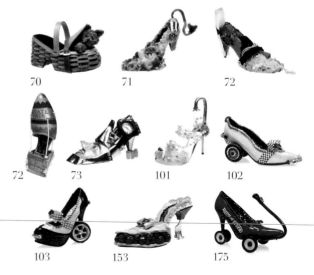

70 71 72

72 73 101 102

103 153 175

DANTE TAPARELLI

Dante's sculptural shoes are comprised of various woods, metals, found artifacts, and shoe lasts. He currently serves as the director of design and urban image for the Ministry of Culture in Rosario, Argentina. He has produced many important projects for the city, including five fashion biennials and an open-air museum and street market with more than 150 antique vendors. In 2012, he was recognized as a "distinguished artist" of the city. www.dantetaparelli.com.

TOMMASO TASTINI

Tommaso works in Plexiglas. Born in Foligno, Italy, he studied at the University of Architecture in Florence. He currently lives and works in Italy. Tomasso5@gmail.com.

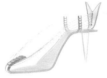

59

118

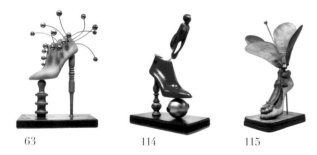

63 114 115

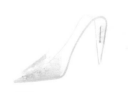

119

136

172 173

137

SHARON VON SENDEN

Sharon's pieces are constructed of stained glass, Swarovski crystals, and vintage stones. She has designed and constructed more than eighteen thousand square feet of mosaics for the City Museum in St. Louis, Missouri, using almost five million pieces of glass, tile, stone, and other materials to cover walls and surfaces. safeharbor13@hotmail.com.

KATHY WEGMAN

Kathy created her shoes from beads, rhinestone chain, and vintage glass pieces. For more than fifteen years, she has worked with her husband, Tom, to create intricate beadwork. While Kathy has beaded many different objects over the years, shoes remain her favorite. www.tomandkathywegman.com.

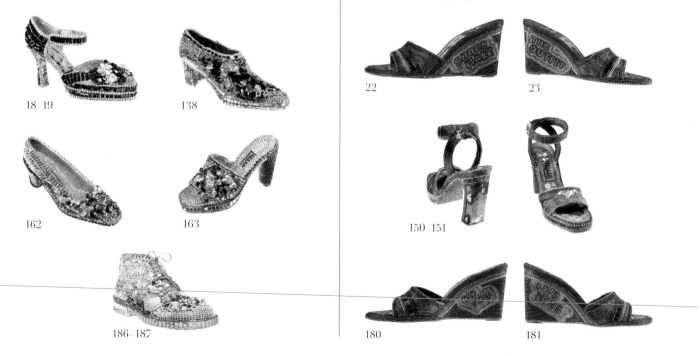

18–19 138

162 163

186–187

22 23

150–151

180 181

SYLVIA WEINSTOCK

Sylvia's shoes are made of frosting. Often called the "Leonardo da Vinci of Cakes," she has created extraordinary celebratory cakes since 1975 and has become world-renowned for her delicious, artful confections. Sylvia's business is based in New York City. www.sylviaweinstock.com.

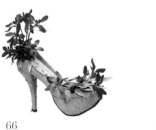

66

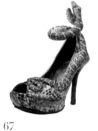

67

DRAKE PHILLIP WESSON

Drake created his shoes from low-fired ceramic. His popular ceramics are influenced by art deco designs. A long-haul flatbed semitrailer driver, he resides in California. www.facebook.com/ArtisansDrake.

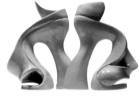

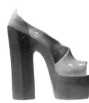

40

41

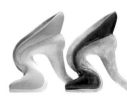

120

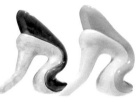

121

DOUGLAS WILSON

Douglas constructed his shoes from wire and acrylic film. He has been making automata since 1996, and his pieces have received several awards for their originality and design detail. He works mainly in galvanized wire, stainless steel, silver, and acrylic film, composing his pieces with pliers only. His sculptures can be seen in many automata collections worldwide, including the Arima Toys and Automata Museum in Japan. douglaswilson781@gmail.com.

20

21

84

96

97

129–130

149

158–159

184

185

KEITH WINCHESTER

Keith's shoes are constructed of armature wire, silk, resin, and beads. Born in Virginia, Keith has lived in a 150-year-old farmhouse in rural Mississippi for more than thirty-five years with his wife, Ginny. They have one adult son, Seth, and three dogs, Blitz, Gopo, and Lando. keithwinchester@gmail.com.

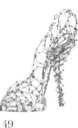
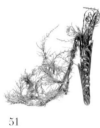

49

51

ACKNOWLEDGMENTS

My parents, Ethel and David Gershon, are no longer with me, but I will always be grateful to them for passing down their love of books and reading, as well as for teaching me so many other valuable things. I also want to thank my immediate family: Stuart, Rachael, Elizabeth, Eric, Eva, Alan, Ana, Ruth, and Selma.

I am especially indebted to Jackie Giusti Seaman for her impeccable taste and good advice, and whose efforts were vital to making this project come to life. My very special thanks to Tim Fortuna, whose enthusiasm and talent were constant inspirations for the Stuart Weitzman windows and who gave the artists' shoes the best showcases that they could have ever had.

I am also indebted to Irma Wallin for her early proofreading of my introduction and to Jan Kardys, who gave me valuable advice and introduced me to my outstanding literary agent, Jackie Meyer at Whimsy Literary Agency, to whom I am also very grateful. I'd also like to thank Carolyn Hessel, Naomi Firestone-Teeter, Jan Constantine, Phil Kodroff, Barbara Kolsun, Susan Duffy, Hayley Gedney, Michael Mafrici, Richard Keller, Danielle Landry, and Nancy Simpson for their help and support. Many thanks, too, to Allen Kay at Korey Kay & Partners, who was generous with his time as well as his ideas. I am also grateful to Tracy Baldwin and Radio Flyer.

To those who helped track down some of the wonderful artists in the book, I am deeply grateful: Sandra McRitchie, George Carson, and Gillian Betty of Comrie, Perthshire, Scotland, who helped me locate Douglas Wilson in Australia; Paul Clarke at the First Gallery in Southampton, England, and Paul Spooner in London, who led me to Comrie; Raouf Sarwari for finding Tommaso Tastini; Mary Jane Sarvis and Joel Lentzner for their help with Graham Davidson; and Susan Diaz for contacting Dante Taparelli in Argentina.

To the team that helped me produce this book, my heartfelt thanks goes to photographer Lucas Zarebinski, stylist Sarah Guido, and Winting Goo. To Elizabeth Viscott Sullivan, Lynne Yeamans, and Andrea Rosen at HarperCollins, as well as book designer Alissa Faden, thank you so much for your enthusiasm and faith in *Art & Sole* and for working hard to make the finished book as strong as it could possibly be.

Finally, but very importantly, to all of my friends, thank you for your patience and support. I love every one of you.

ART & SOLE

Text and photography copyright © 2013 by Jane Gershon Weitzman

HarperCollins books may be purchased for educational, business, or sales promotional use. For information please e-mail the Special Markets Department at SPsales@harpercollins.com.

First published in 2013 by:
Harper Design
An Imprint of HarperCollins*Publishers*
10 East 53rd Street
New York, NY 10022
Tel: (212) 207-7000
Fax: (212) 207-7654
harperdesign@harpercollins.com
www.harpercollins.com

Distributed throughout the world by:
HarperCollins*Publishers*
10 East 53rd Street
New York, NY 10022
Fax: (212) 207-7654

ISBN 978-0-06-219103-8
Library of Congress Control Number: 2011941335
Book design by Alissa Faden
Printed in China

First printing, 2013

ABOUT THE AUTHOR

Jane Weitzman was the executive vice president of Stuart Weitzman and the first vice president of Stuart Weitzman retail. She spearheaded philanthropy for the company by generating funds to support breast and ovarian cancer research and awareness. Her efforts were brought to life through innovative charity events on the brand's website, such as the Stuart Weitzman Celebrity Breast Cancer Shoe Auction, and its retail stores. She serves on the Trust Board of Boston Children's Hospital.